IMAGES
of America

SOMERSET
One Hundred Years a Town

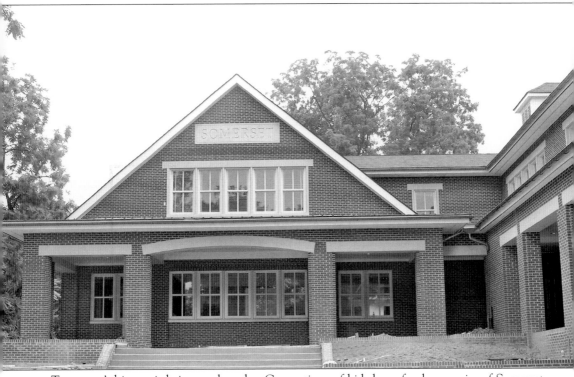

Tomorrow's history is being made today. Generations of kids have fond memories of Somerset Elementary School, which opened its doors to 138 new students in 1928. Through the years, the school grew to meet the needs of the growing populace. As the town celebrates its 100th anniversary, former students won't recognize their old school. This brand new building opened its doors—to a population more than three times the size of the original—for a new generation of children to begin building their own memories and history in the summer of 2005. (Courtesy James M. Boughton.)

IMAGES
of America

SOMERSET
One Hundred Years a Town

Lesley Anne Simmons
with Donna Kathleen Harman

Published by Arcadia Publishing
Charleston SC, Chicago IL, Portsmouth NH, San Francisco CA

Printed in Great Britain

Library of Congress Catalog Card Number: 2005927108

For all general information contact Arcadia Publishing at:
Telephone 843-853-2070
Fax 843-853-0044
E-mail sales@arcadiapublishing.com
For customer service and orders:
Toll-Free 1-888-313-2665

Visit us on the internet at http://www.arcadiapublishing.com

On the Cover: Somerset children are in costume for a 1928 pageant performance. Pictured from left to right are Jane Dunbar, Harriet Balcom, Margaret Balcom, Lois Gish, Louise Watkins, Margaret Saylor, and Lois Cremins. (Town of Somerset collection; courtesy Dorothy O'Brien.)

CONTENTS

ACKNOWLEDGMENTS

Many, many people have contributed to this history. It never would have been written were it not for the efforts of our early historians: Dorothy O'Brien prepared our first history booklet for Somerset's 50th anniversary in 1956 and collected many documents and early photographs; Helen Jaszi helped update it a quarter of a century later; Joan Weiss documented the history of the town, and particularly of the school, for the bicentennial; Donna Harman documented the histories of early houses and their inhabitants. More recently, the residents of Somerset have come together to share their memories at our annual History Days, where they have also shared their photographs and memorabilia. Thank you.

Many people spent time searching through their photographs so that we could illustrate our town's stories. Those whose pictures appear in this book are acknowledged along with their images. I am sorry that, because of space limitations, all of the marvelous photographs so graciously donated could not be included. Assistance from outside of the town has been particularly gratifying —people like Kim Flottum, editor of *Bee Culture* magazine; Pat Jernigan, granddaughter of Mayor Jesse Swigart; LeRoy King Jr.; Pat Andersen at the Montgomery County Historical Society; and many others went beyond the call of duty to help.

Corrie Morsey tirelessly answered questions and dug up facts, figures, and images. Donna Harman's assistance in planning tea parties and scanning photographs as I interviewed residents has been invaluable. I want to thank my friend Jill Roessner for editing the manuscript and my husband, Jim Boughton, for his support and patience throughout the project. But mostly, thank you to the town of Somerset, its government, and its people for being such a fascinating and wonderful place to explore.

—Lesley Anne Simmons

INTRODUCTION

Originally set down among Maryland tobacco fields, the town of Somerset now rests like an oasis of tranquility between the bustling apartments, shops, and restaurants of Friendship Heights to its south and Bethesda to its north. The town retains an image of gentility, with swathes of parkland and green space buffering it from its more developed neighbors; narrow, tree-lined streets; a little red town hall; and a warm and neighborly atmosphere. But that gentility belies a century of effort —first to develop the town and bring its citizens the services that modern-day living required and later to stem the tidal waves of urban development that periodically threatened to overtake it.

Five Department of Agriculture scientists purchased Somerset Heights in 1890. They each built a home, subdivided the remaining lots, and built on them for speculation. By 1905, 35 families lived in the community, but only about one-third of residents were contributing toward the common good. A town citizen association therefore petitioned the State of Maryland legislature for municipal powers to enable them to levy taxes. The charter was issued on April 5, 1906, and the community of Somerset Heights, along with some surrounding farms and land, became the town of Somerset.

Today the town of 413 houses is home to some 1,100 people. Somerset has a mayor and a five-person town council, a town hall, its own flag, a swimming pool (and winning swim team the Somerset Dolphins), tennis courts, a batting cage, and significant parks and green space. It has been called the agriculture department colony (in 1890), an artistic garden spot (in 1914), and a Freudian village (in 1980 a resident used this phrase to a journalist because there were 16 psychiatrists living in town; it stuck for a long time). It also has been called a haven for professionals, one of the country's safest communities, a genteel town full of fighters, and a village of rare vintage.

Four major building periods illustrate the town's development, and outstanding examples of homes from each period are still standing today. Between 1890 and 1904, wood-frame two-and-a-half-story Victorian structures with Italian or English picturesque influence were built on large lots. Between 1900 and 1915, Richard and Alphonso William Ough (pronounced Oh) built two-and-a-half-story wood-frame standardized houses on smaller lots for speculation. Between 1915 and 1940, more compact brick one-and-a-half to two-and-a-half story houses in the Colonial Revival style were built. Most prevalent is the two-and-a-half-story side-gabled Georgian Revival, but there are also Dutch, federal, Cape Cod, and some eclectics. From the late 1940s to 1960, the town would triple in size with development of previously-undeveloped land, which brought new street names and interesting modern architecture. These included charming, livable ramblers, mostly built of brick, and some with Colonial features and decorative shutters. Also included were stylish post-and-beam, split-level ranch houses, many with their beams left exposed, which were considered very bold at the time they were built.

The growing town shrunk in size in 1988, when the town de-annexed the 18 acres on which the first of three high-rise condominium towers was erected. The townsfolk, all of whom lived in single

family residences, feared that the tower residents, who would eventually be in the majority, would have different priorities that they could implement by taking over the town government.

Women have always been the movers and shakers in Somerset, and many of them feature in our history. Women organized themselves somewhat informally into the Wednesday Club in 1902. By 1916, the club was formalized and became part of the Federation of Women's Clubs. Although they could not vote in town elections until 1921, women were to take on many civic and social causes and have significant impacts on the way the town was to develop. It did not take them long after gaining the right to vote to become politically involved; the first woman to hold a town post was Dr. June Hull, who was the town's health officer in the mid-1920s. Shortly thereafter, Edna Miller Gish became the first woman elected to the town council in 1928; she had earlier spearheaded the effort to get the school built in the town.

Through the years, Somerset's government and people have ensured that their community is firmly rooted in the modern day, providing residents with services—from street cleaning to winter flu shots and sports and leisure opportunities—undreamed of 100 years ago. At the same time, they retain the traditions of those who came before. The hill on Cumberland Avenue still remains unplowed after snow so that kids and adults alike can sled down its steep slopes only to make the slippery climb up again for the joy of speeding down one more time. Hundreds of neighbors visit each other for trick-or-treat on Halloween night. The town meets in the grounds of the little red town hall building to celebrate July 4th with friends and neighbors and state and local politicians. For decades the town *Journal* has shared news—good, bad, and sad—and offered tips about everything from surviving a snow-storm to recycling, opportunities to buy, sell, rake leaves, or shovel snow for a neighbor, or simply share an opinion. Somerset's history is illustrative of many American communities that have come together under the flag of incorporation to bring about growth and change while maintaining community and neighborhood.

As in all history, it is the labors of everyone who ever lived in, went to school in, or otherwise touched the community that has made our town what it is today. Because of the efforts of town historians who have gone before us, we know a lot about some of them, particularly our founders and mayors, who had great impact on the development of the town. This volume mentions only a small group of those who have been important to our town, but we celebrate each and every person who has touched us.

As the town moves into the 21st century, change continues. One trend is common to many communities: tearing down or adding onto the small houses built in the mid-20th century and replacing them with larger homes that better meet the needs of today's families. More specific to Somerset is the increasing development of Friendship Heights, which lies less than a mile to our south, and the unknown impacts that may have on the town. As with the changes we have faced in the past, not everyone agrees on whether this will be bad or good for the town. Only history will tell us.

One

A SUBURB TO BE FASHIONED AFTER THE VERY PLEASANT ONES OF BOSTON

1890–1906

The land on which Somerset is built had long been a unit. It was part of the original Friendship Tract containing 3,124 acres, which was patented in 1711 by the fourth Lord Baltimore to Col. Thomas Addison and James Stoddart. An early Philadelphia atlas map, dated 1801, shows a 211-acre tract of land known as Friendship that belonged to farmer Richard Williams. One of the most important transactions, as far as the town is concerned, was in 1890, when entrepreneur John Beall and his partner Dr. Ralph Walsh, who then owned some 217 acres of the southwestern part of Friendship, sold 50 acres to five gentlemen for the princely sum of $19,000. Their plans for the land were described in the Washington *Evening Star* of May 17, 1890:

> The scientific men of the Department of Agriculture . . . selected a tract consisting of 50 acres of rolling land adjoining the property of General Drum just across the District line in Montgomery County. The company will begin operations by providing the property with a good system of sewerage, a bountiful supply of water and electric lights for the Georgetown and Tenallytown Electric Railway Company. The lots are to contain no less than one acre, with a view to insuring the building of . . . a suburb fashioned after the very pleasant ones of Boston and other northern cities.

The town founders, all with the U.S. Department of Agriculture, were Dr. Harvey W. Wiley, Dr. Charles A. Crampton, Dr. Daniel E. Salmon, Miles Fuller, and Horace Horton. Together they formed the Somerset Heights Colony Company, and four of them built a large home on a large lot. Mr. Horton did not build; his interests were taken over by Dr. E. A. deSweinitz, who built

his home on Essex Avenue, which was destroyed by fire shortly after its completion in 1895. Not only did the founders want to provide pleasant homes for their families, they also fully expected to make money on their venture. They subdivided the remaining land, split it between themselves, and began building homes for speculation.

Life was not easy or pleasant. Montgomery County was sparsely settled at that time, and no services of any kind were provided. Sylvia Carrigan Smith, who grew up in Somerset, describes it:

> There was no electricity or gas, no street lights, and a boardwalk up Dorset Avenue. When my parents went to Center Market downtown on Saturday nights, they carried a lantern and hid it in the bushes before they took the streetcar and later picked it up to light their way home. But they had two modern conveniences that they did not enjoy in Baltimore city, where they had lived most of their lives . . . an indoor toilet and a telephone next door.

Indeed, by 1905, the broad avenues were still only dirt roads. A citizens association built and maintained the wood sidewalks to protect shoes and clothing from the ever-present mud and filled a great many of the holes in the streets. Wastewater was drained by gravity to low ground. Residences either used outhouses or were connected to cesspools, and nearby streams received the effluent from these arrangements. The Somerset Heights Water and Power Company supplied water to households for a $200 connection fee. A windmill on the hill pumped water from the deep wells on West Cumberland Avenue up to the holding tank. From there it ran by gravity through shallowly laid pipes to nearby houses. During freezing weather, drinking water often could be had only in buckets. Fire protection was minimal, both because of the nature of the water supply and because the nearest fire-fighting equipment was housed a half-hour away at Tenleytown. The nearest county public school was at Rockville, which was some eight miles away. Children attended classes in a rented house between the Offutt and Davidson farms at first, then at the E. V. Brown School in the District of Columbia near Chevy Chase Circle—a one-mile hike across fields and an open stream.

In 1902, Somerset's women had joined together in the Wednesday Club to provide a regular social meeting place for tea, friendship, and an exchange of ideas. One of their community efforts was the purchase of a pressure cooker to share among themselves. This was more than a social club. Members soon pressed for civic improvements and inspection of the dairy farm on Dorset Avenue.

Only about one-third of the 35 families who lived in the community could be relied upon for cash or work contributions for the common good, so, in 1905, the citizens association decided to petition the legislature of the state of Maryland for municipal powers to enable them to levy taxes in order to equalize the burden of providing essential services for all.

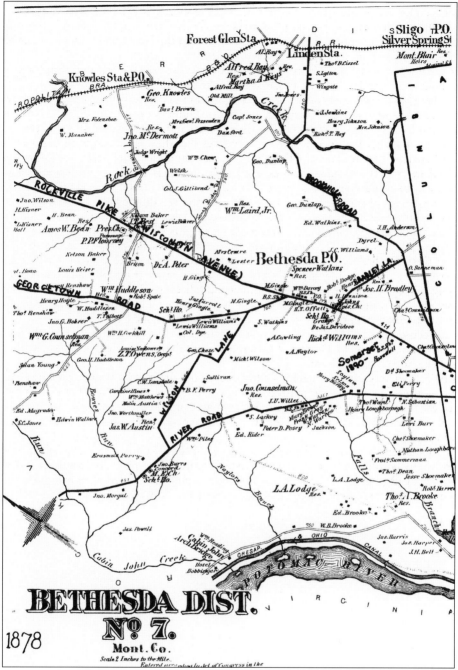

This 1878 Bethesda District No. 7 map shows part of the Friendship tract with the Richard Williams residence labeled where Somerset now lies. The land had changed hands several times since Williams owned the farm, although his name is still listed. He was only one of many farmers whose acreage lay along the Rockville Pike. More than a dozen 100-acre farms flourished to the north and south of the Williams farm between Bethesda and the District line. Note that an earlier Somerset historian has marked "Somerset 1890" and the modern names of streets (Wisconsin Avenue over the Rockville Pike label, for example).

11

The founders' brochure described Somerset Heights as tranquil and refined; "views of surrounding country extend from the Virginia bluffs on the south, to the Blue Mountains on the north." Emphasis was put on the convenience to the District of Columbia: "a resident of Somerset can reach the center of Washington in one hour and by May 15, 1891 the trip will be made in 40 minutes." (Somerset community collection; Montgomery County Historical Society [MCHS].)

June Cooper Reynolds recalls the Dorset Avenue entrance to Somerset as familiar for many years. Trolley-car tracks are in the foreground along Rockville Pike (now Wisconsin Avenue). The town mailbox affronts the trolley-car shelter, which was painted yellow-orange with green trim. Sycamore trees, long a landmark for getting off the trolley, are on the left. A paved sidewalk had been constructed alongside the mud road by the time this early-20th-century photograph was taken. (Town of Somerset collection; courtesy June Cooper Reynolds.)

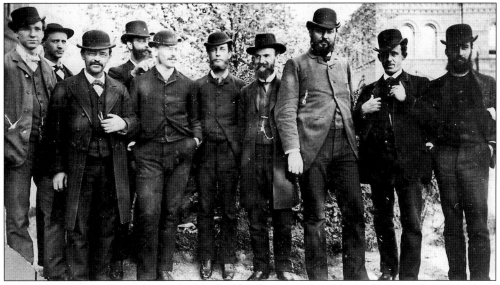

Five gentlemen scientists who worked at the U.S. Department of Agriculture purchased the land on which Somerset was to be built in 1890. Three of them worked for the Bureau of Chemistry. On the far left in this 1890 staff photograph is Miles Fuller, business manager for the venture; third from the right is Dr. Harvey W. Wiley, and far right is Dr. Charles Crampton. Two other founders not pictured here were Dr. Daniel E. Salmon and Horace Horton. (Courtesy the Historical Society of Washington, D.C.)

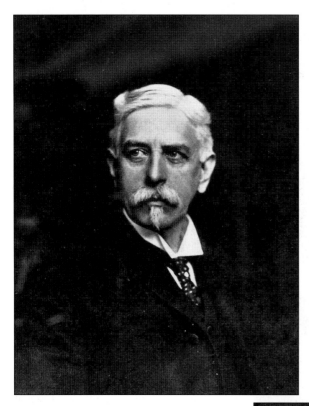

Dr. Daniel Elmer Salmon was the first chief of the Department of Agriculture's Bureau of Animal Industry, which was established in 1884. Best known for identifying the infectious pathogen salmonella, which was named after him, under his leadership the bureau attracted outstanding scientists and accomplished remarkable success in controlling and eradicating many animal diseases. Salmon left the bureau in 1905 following the meat-packing controversy roused by Upton Sinclair's *The Jungle*.

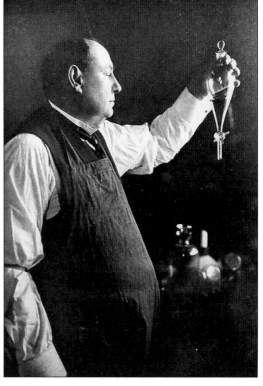

Dr. Harvey W. Wiley, chief of the Bureau of Chemistry, advocated a plain, simple diet and pure, wholesome food. Friends, however, said that he dined on good food and drink in quantities commensurate with his body weight of over 200 pounds. Father of the Pure Food and Drug Act of 1906, Wiley did not live in Somerset. In 1893, he built a home for his parents, but they never left their home state, Indiana, to come to Somerset.

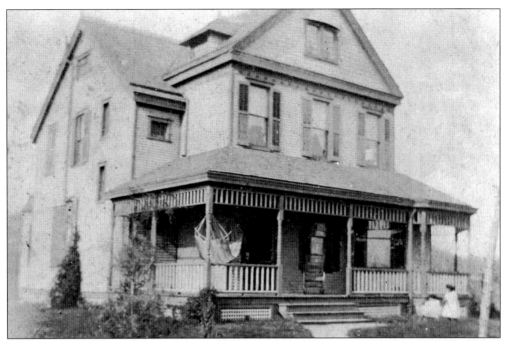

Dr. Charles A. Crampton, Harvey Wiley's assistant at the Bureau of Chemistry, built this home on Dorset Avenue. He was a man of many firsts: not only was his house the first to be occupied (in 1893), but he also served as Somerset's first mayor. His son, Carl, was the first baby to be born in Somerset, and the Cramptons owned the first automobile in town, a Cadillac. (Town of Somerset collection; courtesy Mr. and Mrs. Carl Crampton.)

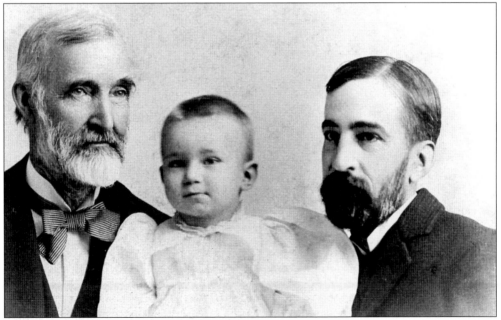

Dr. Charles Crampton (right) is pictured here with his son, Carl (center), the first baby to be born in Somerset (in 1894), and Dr. Crampton's father. (Town of Somerset collection; courtesy Mr. and Mrs. Carl Crampton.)

Miles Fuller built his home on Dorset Avenue in 1894. In 1899, it was the scene of a tragic accident when a servant, Fannie Jackson, overturned a kerosene lamp, setting light to her clothing. She ran from the house with Mrs. Nora Fuller chasing her with a blanket. But Mrs. Fuller could not catch Fannie, who finally fell, exhausted, and died of her injuries. (Courtesy Donna Harman.)

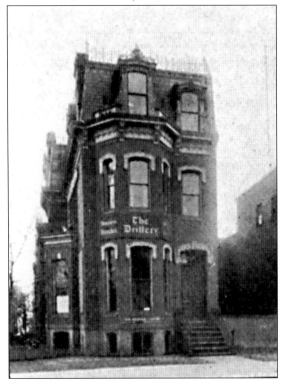

Miles Fuller soon left the Department of Agriculture to open a school for secretaries, called the Drillery, at Eleventh and New York Avenues in Washington, D.C., but he and his wife continued to build homes for speculation on the lots they owned. Fuller sold his Somerset house in 1900 and died two years later, at age 44, of an attack of acute indigestion. (Courtesy the Historical Society of Washington, D.C.)

One of Miles Fuller's four daughters, Mary Claire, was to become one of the most popular (and well-paid) stars of the silver screen, staring in the 1912 Edison series *What Happened To Mary?* and its follow-up, *Who Will Marry Mary?*

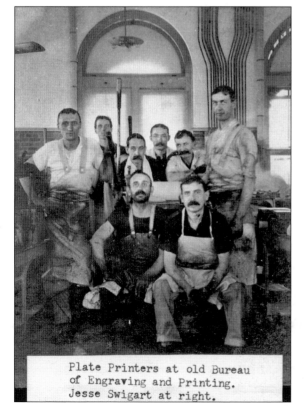

Plate Printers at old Bureau of Engraving and Printing. Jesse Swigart at right.

Among the first to purchase land was Jesse E. Swigart and his wife, Rebecca. Jesse Swigart, front row right in this 1895 photograph, came to Washington in 1891 and soon after became an apprentice plate maker at the Bureau of Engraving and Printing. He quickly rose up the ranks and by 1897 was sufficiently well-established to marry Rebecca Daw, the daughter of a renowned Georgetown builder. (Courtesy Pat Jernigan.)

Rebecca (Bessie) Swigart, with daughter Margaret (age 3) and Elizabeth (18 months), pose in the fall of 1901 on the plank path leading to their newly built Essex Avenue house. The spacious house was built by Bessie's brother-in-law, Alf Ough, who built many other houses in town. Mrs. Swigart maintained a scrapbook of town events, now an important archive of the town's history, which is kept in the Montgomery County Historical Society (MCHS) Library. (Courtesy Pat Jernigan.)

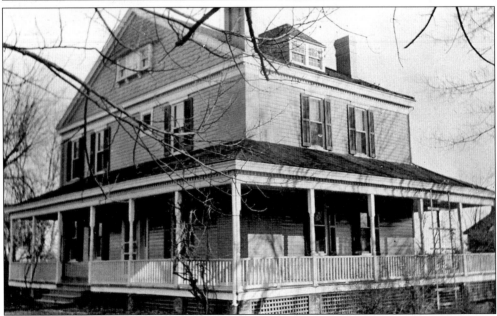

In 1902, John William Stohlman, owner of a confectionery store in Georgetown, and his wife, Annie, bought Clover Crest on Dorset Avenue from town founder Dr. Daniel Salmon. The Stohlmans had nine children: Margaret, Anna, Martin, William, Edwin, Frederick, Helen, Katherine, and Mildred; three of them were born in the house. (Town of Somerset collection; courtesy Mr. and Mrs. Andrew Sheridan.)

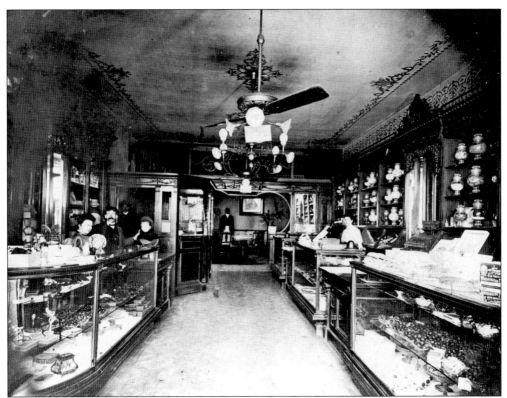

Stohlman's combination ice-cream parlor, candy shop, and bakery on Wisconsin Avenue was typical of those found in most cities at the turn of the century. By this time, refrigeration technology was adequate and common enough to permit widespread marketing of ice-cream products. Shown here c. 1910, Stohlman's was said to have sold the best ice cream in town (for $1 a quart). (Courtesy National Museum of American History.)

Stohlman's store was disassembled in 1950, and a portion of it was rebuilt in the Palm Court at the Museum of American History, where it still stands today.

These views from Warwick Place look toward Rockville Pike (now Wisconsin Avenue), one taken in winter and one in summer. The fenced property is Joshua Callahan's farm, the house being further to the left (not pictured). The diagonal path formed a shortcut from Cumberland to Dorset for residents en route to Washington. The prominent house belonged to Rufus Lusk. On the near side is a bungalow occupied by the Kipp family (Mrs. Lusk was their daughter). The large house on the other side belonged to the Wilsons. In the center at the left is the community garden, better seen in the summer photograph, where June Cooper Reynolds recalls her grandmother, Mary Brady, had a plot. (Courtesy June Cooper Reynolds.)

Just 35 families lived in Somerset in 1906. The children of two of those families, pictured here, pose before a game of croquet. In the back row, from left to right, are Margaret Stohlman, Edwin Stohlman, Margaret Swigart, Elizabeth Swigart, and Anna Stohlman; in front is little Ada Swigart, who was born in January 1903 in the family home on Essex Avenue. (Courtesy Pat Jernigan.)

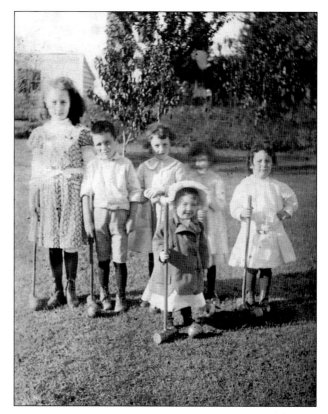

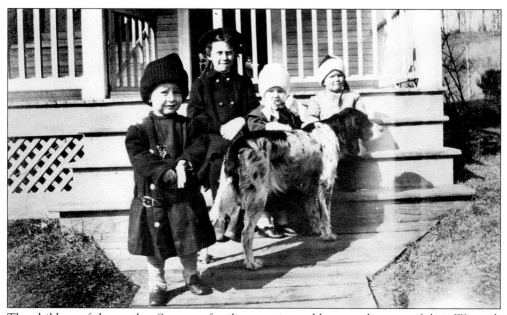

The children of three other Somerset families are pictured here on the steps of their Warwick Place home. From left to right are Rudolph Cox, Irene Rice, June Cooper, and Albert Titus, with dog Belle. (Somerset community collection, MCHS; courtesy June Cooper Reynolds.)

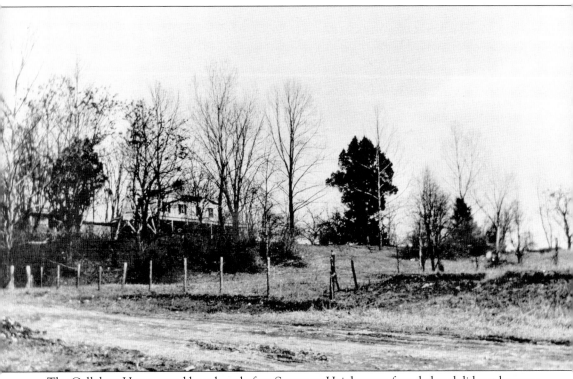

The Callahan House stood here long before Somerset Heights was founded and did not become part of the town until Somerset was enlarged and incorporated in 1906. In the early 20th century, the home was occupied by Mrs. Merchant, whose father, Boss Shepherd, had been mayor of the city of Washington. The muddy, unpaved roads are noticeable in this stark winter scene. If you look carefully, the white struts of a windmill are visible behind a tree to the left of the house. It was on the porch of Mrs. Merchant's house that parents would later register their children for the new Somerset Elementary School in 1928. (Somerset community collection, MCHS.)

Two

Not So Pleasant Yet
1906–1918

The charter was issued in 1906, and the community of Somerset Heights, along with some surrounding farms and land, became the town of Somerset.

The first town council was elected on May 7, 1906, and Dr. Charles A. Crampton became the first mayor. Meetings of the town council were held in the mayor's home or the home of the town clerk-treasurer. The most pressing task was to develop an orderly and fair way of assessing taxes on property within the town boundaries. A board of assessors soon achieved this, and the tax rate was set at 50¢ on each $100 of taxable property. The total expenditures for 1907–1908 were to be $511, of which $350 was for maintaining and lighting streets and sidewalks. This soon proved inadequate, and the subject of a general reassessment was heatedly debated over several months. The attempt failed, although selected properties were reassessed. A more modest revenue-raising measure, a $2 per head tax on dogs, was established instead.

Sanitation received immediate attention. The main sewer, a large terra-cotta pipe that emptied directly into Little Falls Run, was broken and was a health hazard. Another, smaller pipe, which drained into a cesspool west of town, was blocked. The recommended remedy was to extend the pipe past the cesspool location down a gully where it could flow into an open field.

The town was gaining its identity. It requested that the name Somerset replace West Chevy Chase on railroad cars of the Rockville and Georgetown Line. Street signs were completed and house numbers ordered. A town marshal enforced the ordinances, one of which was that "it shall not be lawful for any animal of the goat, horse, cow, or hog kind, or any fowl such as geese, ducks, turkeys, or chickens to go at large within the limits of the . . . town. . . . Provided that this . . . shall not . . . interfere with the driving of such animals or fowls through the streets, roads, or avenues." Signs forbidding hunting were ordered.

The first bond issue, in the sum of $3,000, was approved in 1908 to improve streets and walks. Granolithic sidewalks were laid in place of the wooden slat sidewalks, with half of the costs assessed against abutting properties. The town bought the stone from the old Glen Echo Railway. Traffic was already a concern, and a speed limit was set at 12 miles per hour. The deteriorating frame trolley station was condemned and demolished in 1913, and a little entrance was erected over the sidewalk. The town assumed the title to an unclaimed lot on Cumberland near Rockville Pike on which it planned to build a school.

For the most part, Somersetters traveled across the D.C. line to shop. Amelia Davis ran a little store that sold tobacco, candy, bread, and kerosene on the north side of her house on the

northwest corner of Warwick Place and Dorset Avenue. The first telephone exchange was later located in the rear of her house.

During this period, Somerset women got together at their Wednesday Club; women still could not vote in Somerset. Through World War I, the club formed a busy Red Cross unit and folded thousands of bandages and knit countless sweaters as their contribution to the war effort. In 1916, they founded the Woman's Club of Somerset to provide for wider community service. It was later to become a member of the Montgomery County Federation of Women's Clubs.

Jesse Swigart was elected the town's second mayor in 1910 and Warren W. Biggs the third mayor in 1912. Biggs owned a steam heating business and had the first house in Somerset to have radiators and central heating. He is the only mayor of whom we do not have a photograph. He had acted as the first clerk-treasurer and was elected to the town council in 1909. He was followed by Charles S. Moore, who was elected mayor in 1916.

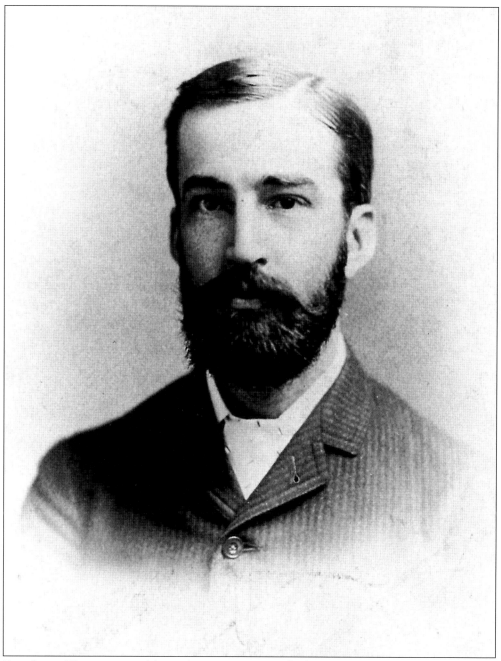

Founder and Department of Agriculture scientist Dr. Charles A. Crampton was elected the first mayor of Somerset on May 7, 1906, along with four councilmen: Jesse Swigart, C. Fred Cook, W. Alf Ough, and John R. Cox. One week later, the first session of the common council met at Crampton's home and set in motion the procedures to appoint a committee to submit a set of by-laws and a board of three assessors; it appointed a clerk-treasurer, Mr. Gibbs; a health officer; and a town marshal; and agreed to place an advertisement regarding tax levy. Crampton would serve two terms as mayor, staying in office until 1910. (Town of Somerset collection; courtesy Mr. and Mrs. Carl Crampton.)

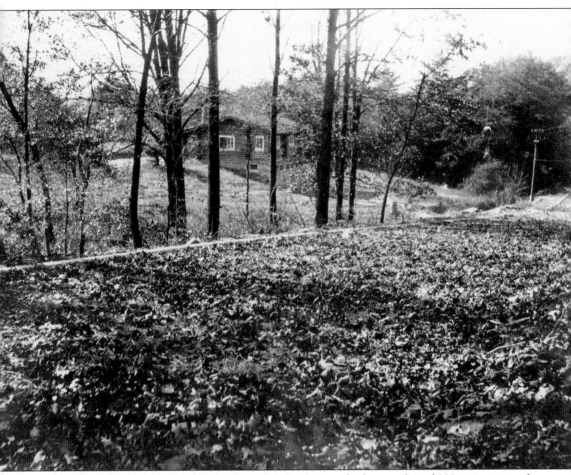

The Somerset Heights Water and Power Company supplied water for a $200 connection fee. A windmill (later replaced by a gasoline and then an electric pump) drew water from wells on Cumberland Avenue to the holding tank. It ran by gravity through shallowly laid pipes (seen in the foreground of this picture of the Jaffes' log cabin) to nearby homes. During freezing weather, drinking water often could be had only in buckets. (Courtesy Dorothy Fischer.)

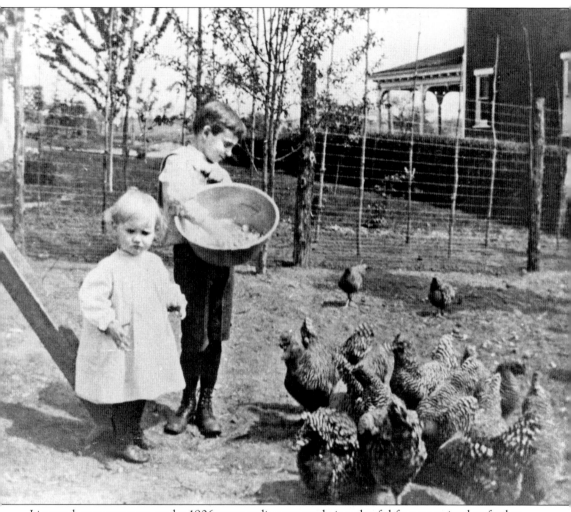

Livestock was common, and a 1906 town ordinance made it unlawful for any animal or fowl to go at large within the town. Pictured here is John Bernard Brady, with niece June Cooper, who lived next door, feeding Plymouth reds in the yard of his mother's Warwick Place home in 1907. Mary Margaret Brady, John's widowed mother; John; and two sisters, Estelle and Lillian, moved to Somerset in 1906. (Somerset community collection, MCHS.)

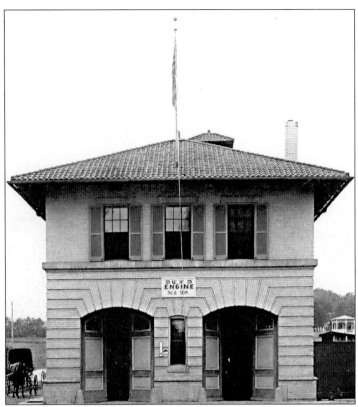

In 1907, the captain of Station No. 20 at Tenallytown (shown here) and the chief of the D.C. Fire Department were "disposed to offer us fire protection if we supply them with water facilities," according to the minutes of the town council meeting. But the journey from Tenalleytown (now known as Tenleytown) by horse-drawn engine took so long that a fire had done its worst by the time firefighters arrived in Somerset. Seen below in 1914, horses race out of the truck bay to a report of fire. (Jackson Gerhart Collection.)

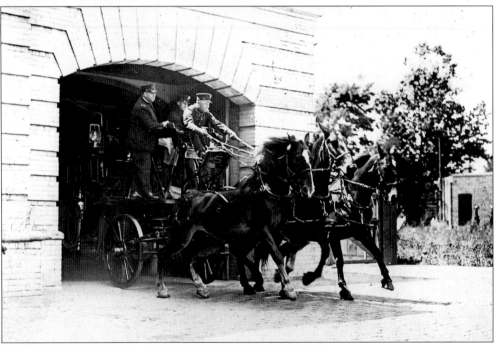

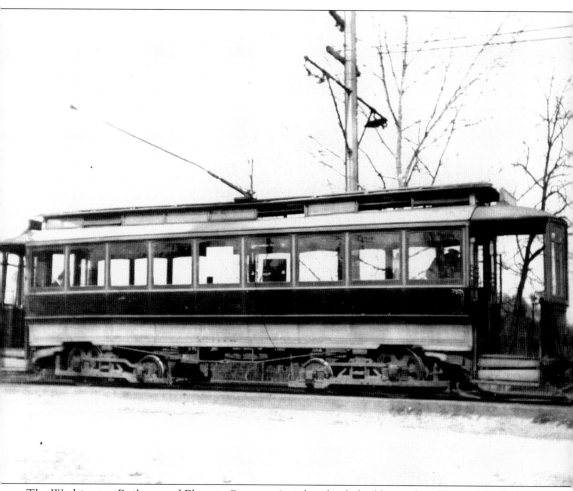

The Washington Railway and Electric Company's eight-wheel, double-truck trolley car No. 503 is pictured here in May 1908. It ran along Wisconsin Avenue to Rockville, turning back at the end of the double track in Somerset. Made about 1900 by splicing two smaller cars together as a money-saving idea, it was scrapped in 1912. First signed West Chevy Chase, in 1908 the town council requested it be signed Somerset. (Photographed by LeRoy O. King; courtesy of LeRoy King Jr.)

Photographed on the porch of the house built for him by brother-in-law William Alphonso (Alf) Ough, Jesse Swigart was a member of the first town council elected in 1906. He was elected to serve as the town's second mayor from 1910 to 1912. (Town of Somerset collection; courtesy Mr. and Mrs. Laurie Hess.)

MAY 3	MAY 4
1909 Monday Town election Biggs and Cooper elected in place of Cox and Ough.	1909 Tuesday — Meeting at Gibbs Cooper declined to serve on Council.
1910 Tuesday. Worked ⅛ day Went to Rockville to take oath as Mayor of Town of Somerset. Cut grass for 2nd time in evening. Council meeting	1910 Wednesday Ada & Pat came to Somerset to stay a week. Staying at Lily's. Biggs has promise of $700 settlement in Burrows with Bond
1911 White hen due to hatch.	19
19	19
19	1913 Sunday See entry on May 11th for this day.

Jesse Swigart's diary for the day after he was elected mayor, May 3, 1910, shows a busy schedule. He had to go to Rockville to be sworn in as mayor and to a council meeting that evening with council members Warren Biggs, C. Fred Cox, W. C. Folson, and W. Alf Ough. (Courtesy Pat Jernigan.)

Charles Wise, shown here with his chickens, was an auditor for the railroad company and served as the town's clerk-treasurer from 1909 until he moved out of town in 1912. He received $2 for each meeting he covered, for which he wrote minutes, drafted letters, and kept the accounts. Wise bought his Somerset home in 1904, married soon after, and a daughter, Virginia, was born in the house in 1907. (Courtesy Virginia Goff.)

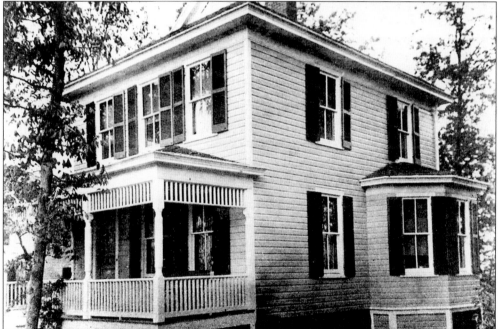

Meetings of the town council were held here in Charles Wise's home (pictured here in 1905) while he served as clerk-treasurer. On December 8, 1910, a special meeting to discuss an amendment to the town charter to authorize the town to construct sewers and assess the cost against properties abutting the street was held. Not surprisingly, there was a large turnout. One can imagine the front parlor was very crowded. (Somerset community collection, MCHS.)

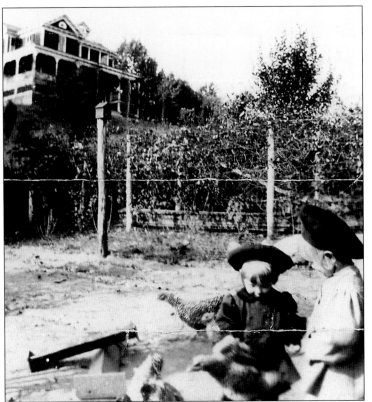

The Sutcliffe House, on Cumberland Avenue, is behind the girls playing in the Coopers' yard. June Cooper recalled, "It was very imposing—large, red, with fancy white trim." In July 1909, it burned to the ground. Sylvia Carrigan Smith recounted the arrival of horse-drawn fire engines from Engine Company 20 in Tenleytown, and "by the time [Dr. Sutcliffe] was within sight of Somerset he could only watch helplessly the destruction of his home." (Somerset community collection, MCHS; courtesy June Cooper Reynolds.)

After the fire, Dr. Sutcliffe built a bungalow on the site, which the family used in the summer only. Mayor Biggs's house (on Cumberland Avenue) can be seen peeking through the trees on the left of the picture. Warren Biggs was in the steam heating business, and his home was the first to have central heating in Somerset. Biggs served as the town's third mayor from 1912 to 1916. (Somerset community collection, MCHS.)

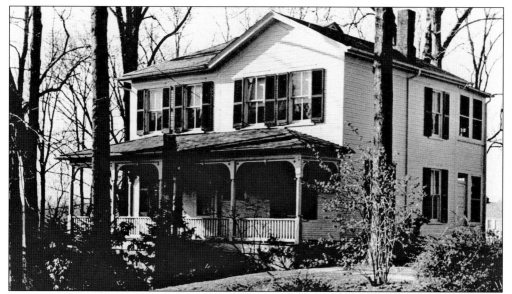

William Horne moved to this Cumberland Avenue home in 1912 and lived here until 1961. The home was built by Richard Ough for his son Alf around 1901; the electric switch to operate the town water pump was in the kitchen. In the early days, Horne family members often were summoned to the back door by neighbors asking that they "please turn on the switch. There is no water in the water tower." (Town of Somerset collection; courtesy Mr. and Mrs. Robert Horne.)

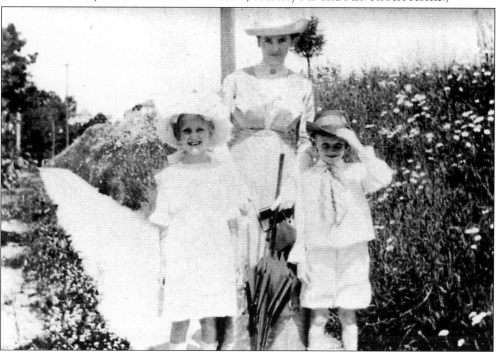

Estelle B. Cooper walks with her daughter June and son Bernard on Dorset Avenue in 1913. On their left (to the right of the picture) is the field with the diagonal path that formed a shortcut to Cumberland Avenue, abundantly filled with daisies on this early summer day. (Somerset community collection, MCHS; courtesy June Cooper Reynolds.)

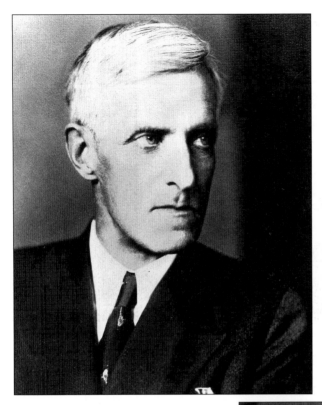

Charles S. Moore, an attorney and real estate investor, served as mayor from 1916 to 1919. When he died at age 94, his daughter, Margaretta, cleared out 60 years worth of accumulation of papers from his Cumberland Avenue home. They included the town's early tax records and the papers of incorporation for the Somerset Water and Power Company, which are now held by the Montgomery County Historical Society. (Town of Somerset collection; courtesy Mr. Allan Vogt.)

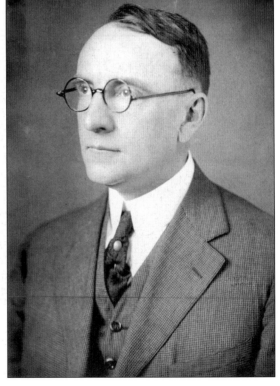

Dr. Everett Franklin Phillips built a house on Surrey Street in 1903. He lived in Somerset for more than 20 years, during which time he worked for the Department of Agriculture's Entomology Division, ran the Somerset bee lab (beginning in 1917), and trained disabled World War I soldiers in beekeeping. In 1925, he left Somerset to take up the position as professor of apiculture at Cornell University. (Courtesy *Bee Culture Magazine*.)

Dr. Everett Franklin Phillips, pictured here in his D.C. office, was to become a renowned expert on bees and beekeeping. While at Cornell, he started what has become a remarkable collection of literature on the topic. Cornell's Albert R. Mann Library now offers free Internet access to the most significant titles from his collection. (Courtesy *Bee Culture Magazine*.)

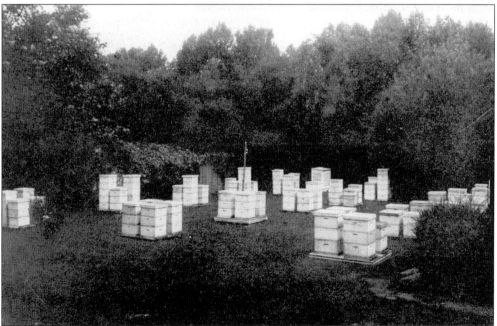

When the bee lab moved to a house on Dorset Avenue, the side yard was filled with hives. Elizabeth Swigart and her friends earned $5 a month during their summer holidays to help with the bees. When the project moved to Beltsville in 1937, John Krynitsky, Ralph Crump, Howard Bryan, and others helped move the bees. John Krynitsky recalls, "First we got the bees into the hives using a smoker. We wore nets over our heads but a bee or two always got in and stung."

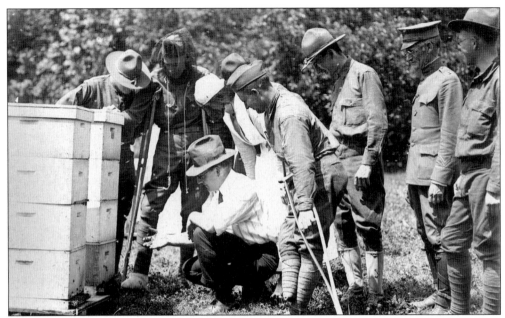

During World War I, both beeswax and honey were used by the U.S. military, and America needed beekeepers to help the war effort. The federal government set up training workshops so handicapped veterans could become beekeepers. Dr. Phillips is pictured here with wounded soldiers around a hive. (Courtesy *Bee Culture Magazine*.)

Dr. Phillips, his wife, Mary, and their three sons are pictured here. Mary was a children's author, and Eleanor Gish recalls that she wrote a story about bees, which she read to the children. Perhaps she was most notable in Somerset, though, for her role in founding the Woman's Club in 1916. In a letter to the club members, written long after she left Somerset to reside in Ithaca, she recalled some of the club's ambitious programs, such as a Dickens tableau, "when men, women, and children were dressed in the costumes of the day and posed as some of Dickens' characters." She also wrote of sharing "the first vacuum cleaner and the first pressure cooker owned by a Somersetter." (Courtesy *Bee Culture Magazine*.)

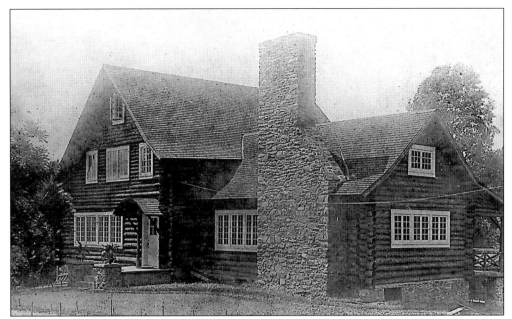

In 1918, Dr. Sidney Jaffe purchased the Crampton House, along with its four acres of property. A dentist and well-known photographer, Jaffe built several other houses on the property. The unusual ten-room stone and Siberian-cedar-log home pictured here was located far from the street in the center of the four-acre tract because of the town's opposition to having a log home in its midst. (Town of Somerset collection; courtesy Mrs. Ernestine Maule.)

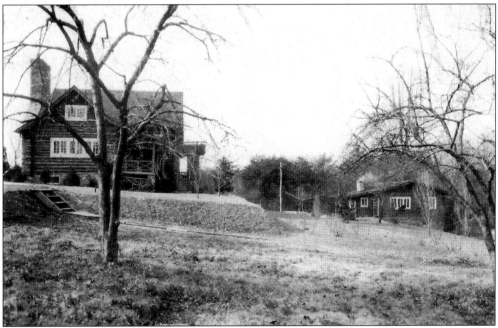

This photograph clearly shows the main home as well as a smaller cabin, to the right, which originally was intended for a servants' home (the family's three-car garage is underneath the living quarters), but the small log cabin was so eagerly sought that it was finally rented to a young couple. (Courtesy Dorothy Fischer.)

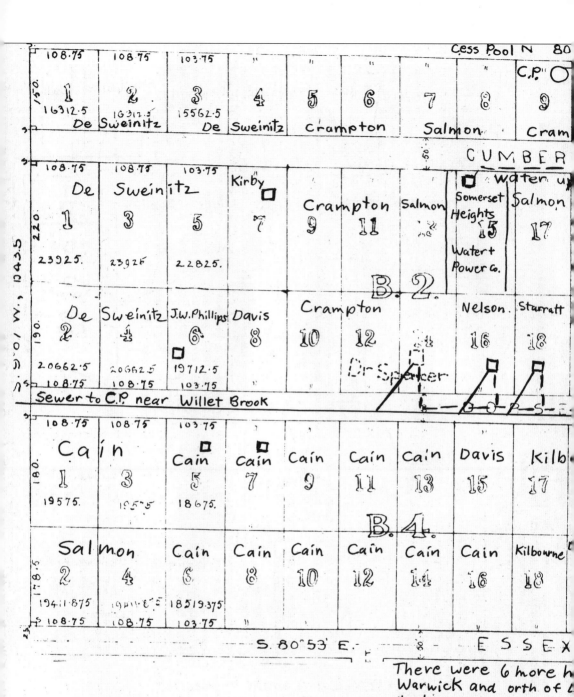

This plat of Somerset Heights has three layers of history: the original plat was filed in March 1899. The names of the property owners, and boxes indicating houses were added, probably by

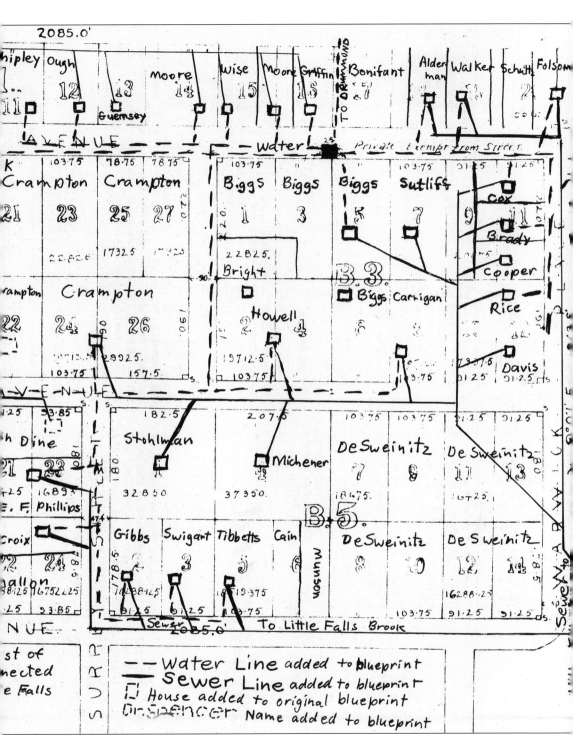

Mr. Ough, in 1912 (many of these names will now be familiar to readers of this book). Sewer and water systems, plus a few more houses, were added in crayon, probably by Mayor Biggs in 1914.

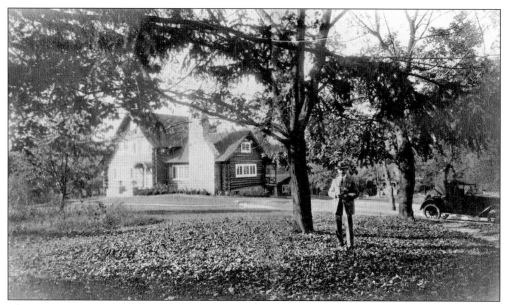

The Somerset Woman's Club annual spring picnic was held on the Jaffes' spacious lawns, shown here with Dr. Jaffe and his automobile. It was reputed that they never were rained out. Mrs. Helen Krynitsky spoke of the Jaffes' hospitality and generosity when introducing Mrs. Jaffe at a Woman's Club meeting in 1958, saying, "The garden parties have always found a welcome on the Jaffe lawns." (Town of Somerset collection; courtesy Mrs. Ernestine Maule.)

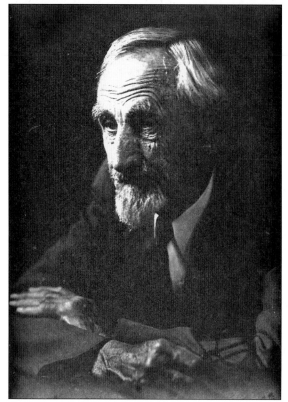

Dr. Jaffe's physician advised him to take up a new interest in 1935. Jaffe went on to become one of the country's top amateur photographers (his work was exhibited in the Smithsonian in 1949). He believed that "a camera portrait individualizes a person, defines his personality, and sometimes tells one much more . . . than even personal contact does." This picture of Somerset neighbor William Crump was taken in 1947. (Courtesy Donna Harman.)

Three

BETWEEN THE WARS
1919–1940

Somerset was still a very small town in 1919. Its population would double to 399 by April 1940, and progress in infrastructure and services was to proceed at a rapid rate under Mayor J. William Stohlman. In 1924, a $40,000 bond issue funded street paving, and the Washington Suburban Sanitary Commission (WSSC) began installing water connections to houses. The streets were paved in 1925, and a carnival organized by the Woman's Club celebrated the achievement. In 1926, mail delivery to residents' homes replaced delivery by horse and buggy to a cluster of mail boxes at Surrey and Dorset. A new firehouse in nearby Bethesda was completed in 1926.

All these initiatives made for tight budgeting, and, in the early 1930s, when Mrs. Bergdoll, owner of many undeveloped acres, failed to pay taxes on her property for two years in a row, the tax rate had to be increased. Property owners who were delinquent on taxes risked their properties being put up for sale at auction, and the town purchased several of Mrs. Bergdoll's lots at such tax sales. The town unsuccessfully applied for a public works grant to help pave those streets as yet unpaved and repave those in need of repair in the late 1930s. Subsequently, several loans were taken out to help meet those costs.

Maintenance worker Henry Genus began working for the town two days a week in 1937, and Clark C. Banes's garage was rented to store the town tools for $2 per month.

The Maryland-National Capital Park and Planning Commission tentatively zoned Somerset Residential A, which the council approved, but at the same time, the council presciently protested any industrial development adjacent to the town.

In 1921, women won the right to vote in town elections. In 1928, Edna Miller Gish became the first woman to be elected to serve on the council and, in 1940, Lou Prentiss Childs the second.

In early 1928, a school committee under the leadership of Mrs. Edna Miller Gish pressed for a school in Somerset. Until then, most Somerset children walked more than a mile across fields and creek to get to Mrs. Givens's Chevy Chase School on Connecticut Avenue. By May 1928, the school board had purchased the Callahan land from Grace Meadows for $38,500 and in June let the contracts for school construction and furnishing for a total of $40,849. Parents registered their children on the front porch of Mrs. Merchant's house, and, in October, 138 students began working in the still-unfinished eight-room building with their six teachers and 25-year-old teacher-principal Kathryne Bricker.

By the 1930s, most homes were connected to a sanitary sewer, although as late as 1932, the health officer, Dr. June Madison Hull, reported unsanitary conditions in Little Falls Creek and

Willet Creek resulting from sewage being dumped into them. It was found that four houses in town were not connected to the new sewer, but that their lines were emptying into the creeks. Within a month of that report, all town houses were connected to the new lines.

In 1935, Wisconsin Avenue was widened, triggering the need to replace the stone pillars that guarded the Dorset Avenue entrance to town.

Traffic remained a perennial problem. In response, in 1931, a policeman was assigned to the town to stop cars for speeding. Seven years later, 13 residents of Dorset Avenue called attention to the danger of heavy traffic, speeding, and reckless driving on Dorset Avenue, and a special officer was employed to enforce the speed laws. When the marshal undertook a survey of stop signs on Warwick and Dorset Avenues, he found them to be poorly observed.

In 1940, a number of citizens petitioned the council to take action to "prohibit the harboring of cows, horses and ponies within the limits of the town." A referendum showed voters preferring, by 66 to 22, an amendment to Ordinance 66 prohibiting such animals, and the following month the ordinance was so amended.

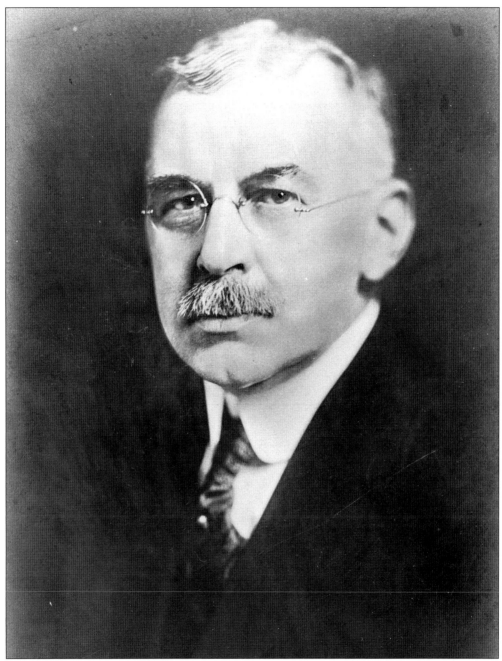

John Stohlman was elected the fifth mayor of Somerset in 1919, a position he held until 1938. The Stohlmans had nine children, three of them born in the Somerset home. Local legend has it that the children all had birthdays in the summer and that their ice-cream-and-cake birthday parties (Stohlman owned an ice-cream parlor and pastry shop in Georgetown) were long anticipated by Somerset's younger generation. (Town of Somerset collection; courtesy Mr. and Mrs. Andrew Sheridan.)

One of Mayor John Strohlman's children, Mildred Stohlman (left), is seen posing here in 1921 with her friends and neighbors, Dr. Jaffe's children, Ernestine and Victor Jaffe.

The trolley remained the primary means of transport in 1920, and shopping trips were few and far between. Mrs. Mary Phillips recalls that "the nearest store was down at the District line. . . . Once when I saw my husband coming up the road with a man with a suitcase and realized we were having an overnight guest, I was in despair, for the main dish for our dinner was a can of salmon! I dashed next door to Mrs. Van Dine, who was just lifting a roast from her oven. 'Here,' she said, 'you take the roast and send one of the boys over with the salmon.'" (Courtesy Joan Weiss.)

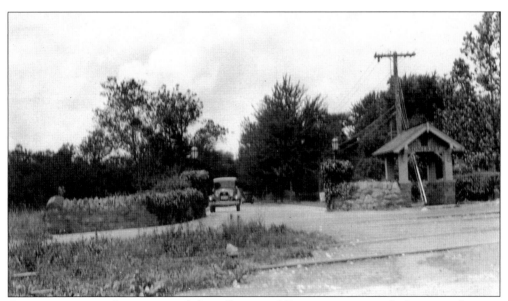

Cars were increasingly seen around the still-unpaved Somerset streets, and what was to become a perennial problem—speeding—began. The speed limit was set at 12 miles per hour in 1916. It was raised to 15 miles per hour five years after this 1920 photograph was taken, when street paving was completed in 1925. (Courtesy Pat Jernigan.)

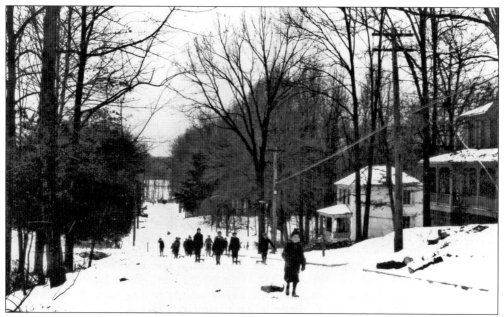

The sledding hill brought children to Cumberland Avenue on winter days such as this one in 1920. Jane Dunbar remembered, "My father bought a Tuxedo racer. It was the top of the line like the Flexible Flyer. It was long and narrow, and he got it for $10. We used to pile on that sled on top of each other, boys and girls together, and then sometimes we'd have two sleds going side-by-side, and at the bottom they'd steer in opposite directions, and there would be people all over the place." (Courtesy Vanessa Piala.)

Sylvia Carrigan Smith and neighbor Bobby Moore pose outside the Carrington house on Dorset Avenue with their sled in January 1922. (Courtesy Joan Weiss.)

Mrs. Margaret Smith bought this Warwick Place house, built around 1902, in 1921. Original owner Mrs. Amelia Davis sold tobacco, candy, bread, and kerosene from the one-story, flat-roof wing on the right of this 1925 photograph. Somerset's first telephone exchange also was here; Mrs. Davis's daughter was the operator. Mrs. Smith rented the home to the Gish family in 1923 for two years, while their Essex Avenue home was being constructed. (Courtesy Eleanor Gish Crow.)

Mrs. Margaret Smith would greet neighbors from her front porch and chat amiably with them as they walked to and from the trolley. At Halloween and Christmas, everyone knew her house would be elaborately decorated, a tradition her son Billy continued when his mother moved away and he and his family took over the family home. All together, the Smith family lived in the home for more than 60 years. Margaret Smith was Somerset's first representative to the county library council in 1942. (Town of Somerset collection; courtesy Margaret Smith.)

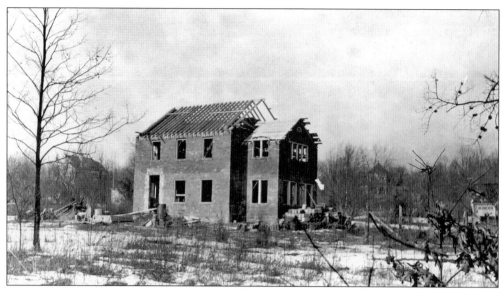

The Gish house on Essex Avenue, under construction in the winter of 1924–1925, was built by Carl Markham. The Fuller house on Cumberland Avenue can be seen in the background to the right of the partly-built house. (Courtesy Joan Weiss.)

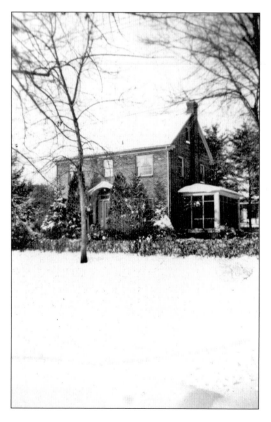

About the same time, Victor and Elisabeth Norling had this home built on Essex Avenue. Swedish immigrants who had met in the United States, they had two daughters, Anne and Marguerita (known as Rita), and a son, Richard Victor (Richard was nicknamed Jimmy by his mother after the mischievous Jimmy Dugan comic strip character). Victor Norling, a piano builder and tuner by trade, served as the town's marshal from 1945 to 1952. (Courtesy Rita Norling Verkouteren.)

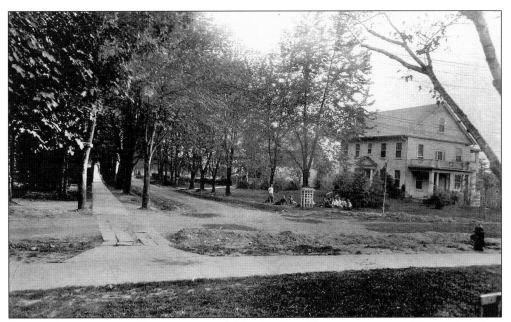

Somerset's streets were still unpaved, although the sidewalks were now granolithic rather than wooden. This photograph, taken from Dorset Avenue looking down Surrey Street in the early 1920s, shows Dr. Everett Franklin Phillips's house on the corner with a crowd of boys sitting on the front lawn. Already many young trees are filling out to shade both sides of the street. (Courtesy Nancy Galler.)

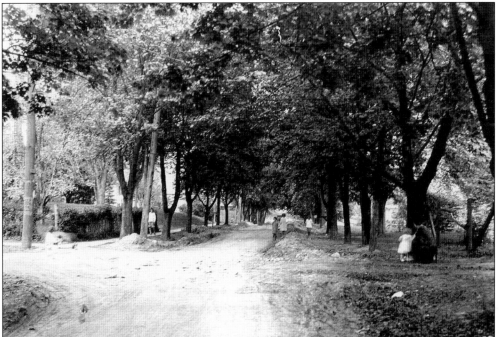

The quickly maturing trees are apparent in this view looking up Dorset Avenue toward Rockville Pike (now Wisconsin Avenue) from the intersection at Surrey Street, also taken before the streets were paved. (Courtesy Nancy Galler.)

In 1924, the town went about paving its streets. Here children enjoy playing in the curb forms workmen have left outside the Dr. Hull House on Essex Avenue at the end of the day. From left to right are Lois Gish, Margaret Saylor, and Eleanor Gish. (Town of Somerset collection; courtesy Mrs. Margaret Saylor Henderson.)

You are cordially invited

To attend the Somerset Street Carnival

to be given on

Saturday, May 30, from 4 to 8 o'clock

on Essex Avenue, Somerset, Md.

The Carnival is a formal celebration of the opening of the new streets and is given under the auspices of the Women's Club of Somerset. The residents of Somerset, in costume, will form in line on Warwick Place and will march by Dorset Avenue and Surrey Street to West Essex Avenue where a pageant, entitled "Somerset," will be given by the children. After the pageant attractive side shows will be offered for your patronage. You are also expected to buy your supper on the street. Salads, sandwiches, coffee, ice cream, cake, punch, and candy will be sold.

Come and enjoy a pleasant evening with your Somerset friends.

Automobiles may be parked on Dorset Ave. between Wisconsin Ave. and Warwick Place.

The Woman's Club organized a carnival and parade to celebrate completion of the street paving the following year. (Somerset community collection, MCHS.)

Nanita Balcom wrote a one-act play that was performed by the town's children. (Somerset community collection, MCHS.)

"SOMERSET"

A SYLVAN DRAMA IN ONE ACT

By NANITA McD. BALCOM

SCENE I, MORNING

Beauty asleep upon her bed of roses is surrounded by the Flowers, the Winds, the Fairies, and Bees. She is awakened by the kiss of the East Wind as dawn appears and the Fairies take flight.

SCENE II, NOON

The Court of King Somerset assembled. The Winds pay homage. The Fool brings in a wandering Minstrel, who relates the story of the Kingdom's Founding by Wise Men fleeing from the City and the treasure of gold buried beneath the Western Hill. Urged thereto by My Lord of Dorset, Prime Minister, the Lords of Warwick, Essex and Cumberland are sent to seek the treasure. Dance of the Flowers. Dance South Wind with the Bees. Dance of Winds. Passage of the North Wind. The Fool is sent and returns bringing captive the Spirit of Beauty.

SCENE III, EVENING

Beauty reclines upon her bed of roses. Lullaby.

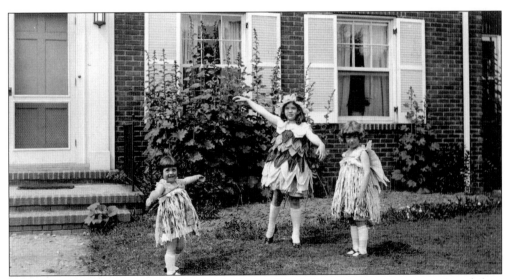

Practicing for their parts in the play on the lawn of their Essex Avenue house are, from left to right, Pauline Gish as a fairy, Eleanor Gish as a rose, and Lois Gish also as a fairy. Eleanor recalls that the fairy dresses were yellow, and her dress was in the colors of roses—red, pink, and green. (Courtesy Eleanor Gish Crow.)

Eleanor Gish recalls her childhood in the family's Essex Avenue home. "People didn't have cars (although our father did, he bought a new Chevrolet for $980). Everything was delivered: milk, ice (there was a door to the fridge that opened from outside of the house where the delivery men would put milk and ice). A man delivered vegetables; there was a baker (Holmes, I think), a Fuller brush man, and a knife and scissor grinder." (Courtesy Eleanor Gish Crow.)

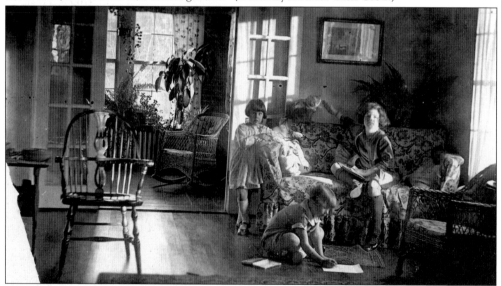

Inside their Essex Avenue house are, from left to right, Pauline, Lois (drawing on the floor), and Eleanor Gish. Sitting on the back of the sofa is their cat, Rahja. The Gish children remember that there were no houses across the street. Eleanor points out, "That's where the woods and the Bergdoll property were. We used to climb a big sycamore tree where we had several 'rooms' to play in." (Courtesy Eleanor Gish Crow.)

From 1908–1940, Sears, Roebuck, and Company sold more than 100,000 homes through their mail-order *Modern Homes* program. This Rembrandt six-room Colonial model, available from about 1921 to 1926, was built for John Brady and his wife, Mary. Completed in 1925, its cost was listed in the Sears House Catalogue as between $2,400 and $2,770. It survives today, looking, despite additions and renovations, very similar to the original. (Somerset community collection, MCHS.)

John B. Brady, an ensign in the U.S. Navy, later became a successful patent attorney. He was elected to the town council in 1944. He and Mary had four children; one daughter entered the church and became Sister Marion Brady, president of Immaculata College in Washington. Theresa Brady Donohue became director of Amherst Ballet Center; a son, the Reverend John Brady, became the pastor of St. Joseph's Catholic Church in Pomfret, Maryland; and Rupert J. Brady became a patent attorney like his father. (Somerset community collection, MCHS.)

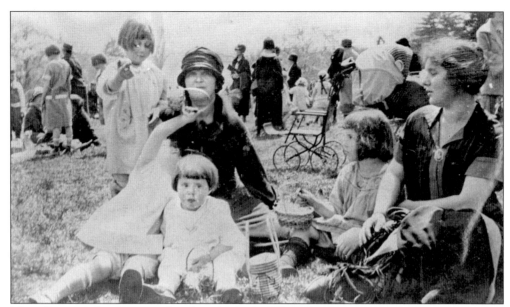

Many Somerset families were close friends. At the White House Easter Egg Roll, Easter Monday, 1925, are, from left to right, Margaret Saylor (standing), Josephine Saylor, Lois, Pauline, and Eleanor Gish, and Mrs. Edna Miller Gish. The two women were prominent in early Somerset—Mrs. Gish for pushing for the establishment of the Somerset Elementary school and as the first woman to be elected to the town council, and Mrs. Saylor as the school dietician. (Town of Somerset collection; courtesy Mrs. Margaret Saylor Henderson.)

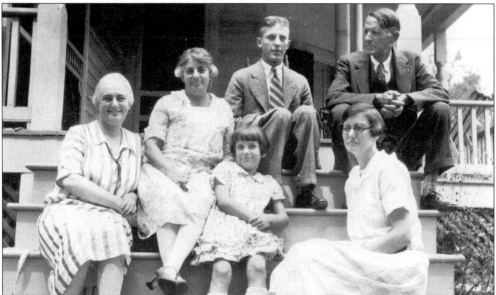

Somerset's early families remained in the town and enjoyed its growth and improved services. This photograph of the Daw sisters (now Rebecca [Bessie] Swigart and Lilyan Ough) and their husbands and children—they all moved to Somerset before it was incorporated—was taken in June 1927 when Margaret Swigart graduated with an medical doctor's degree from Johns Hopkins. From left to right are Rebecca (Bessie) Swigart, Lilyan Daw Ough, Lilyan Ough (age 4), Clarence Ough, Margaret Swigart, and W. Alf Ough. (Courtesy Pat Jernigan.)

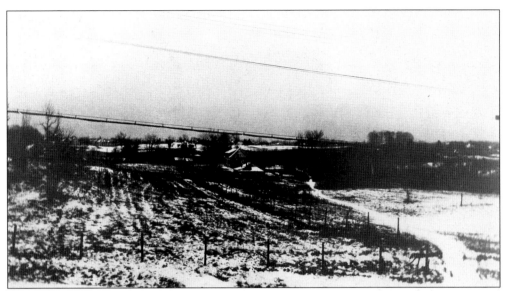

From the early 120th century, children hiked across fields like this to increasingly crowded schools. In 1913, the villages of Drummond, Friendship Heights, and Somerset got together to push for a local school. The result was classes held in the shoemaker's house in Friendship Heights. Somerset appropriated funds ($10) to build a bridge across the stream between Somerset and Friendship Heights for the convenience of schoolchildren, but most Somerset children still walked more than a mile to Mrs. Givens's Chevy Chase School, later named E. V. Brown. (Somerset community collection, MCHS.)

In February 1928, the Somerset School Committee, headed by Edna Miller Gish, requested that the town support its efforts to press the board of education to establish a school in Somerset, which it did. Edna Gish, pictured here with her son, Donald, was elected to the town council that same year; she was the first woman to serve on the council. (Town of Somerset collection; courtesy Mrs. Margaret Saylor Henderson.)

In May 1928, the school board purchased the Callahan land from Mrs. Grace Meadows for $38,500, and, by October, children, including Ralph Crump, pictured here, were attending classes in the new red-brick building. Ralph was nine years old and clearly remembers his parents registering him for school on the porch of Mrs. Merchant's house. (Courtesy Donna Harman.)

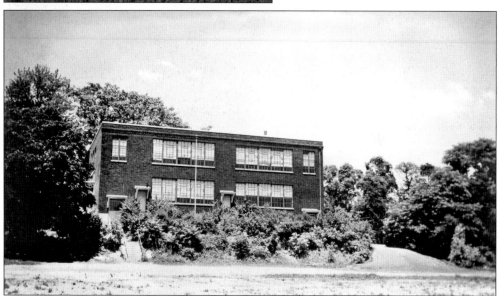

Kathryne M. Bricker, school principal from 1928 until 1965, described the school: "The building was hideous, with red-brick walls, no paint, ceiling lights, only two lavatories for the whole building, and oiled floors to keep down the dust. The children's desks were screwed to the floor. There was a full-time teaching principal and a secretary: Just one clock and one telephone—in the hall. The bell was rung by hand in the principal's classroom, and the child who had that job felt very important." (Town of Somerset collection; courtesy Mrs. Bricker.)

The community continued to be heavily involved in the school. Kathryne Bricker, pictured here, noted that "most PTAs in the county were women's organizations that had afternoon meetings, but we (Somerset) decided to see that fathers were involved, so our PTA meetings were always at night when they could attend. . . . A man was always president." (Town of Somerset collection; courtesy Mrs. Bricker.)

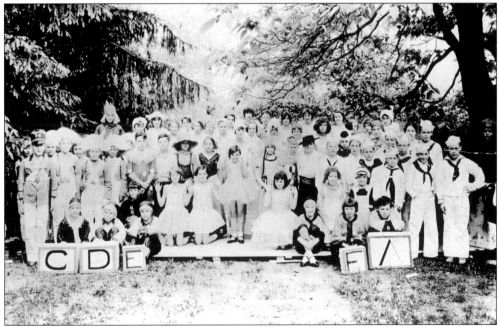

The Somerset School operetta, titled *Toyland* and performed in June 1930, established a long tradition of school performances. The cast is pictured here on the school lawn near the main entrance at the southern end of the building. (Town of Somerset collection; courtesy Mrs. Margaret Saylor Henderson.)

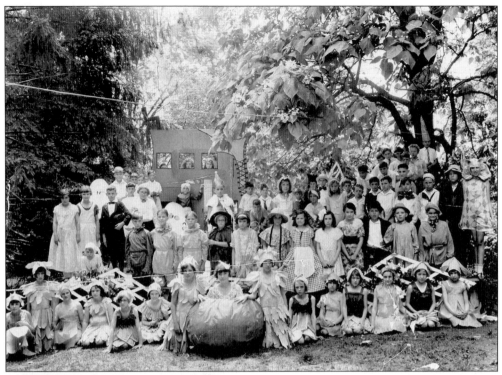

Young actors and actresses of the school's second performance—the operetta *Mother Goose*—pose on the school lawn in 1931. (Courtesy Donna Harman.)

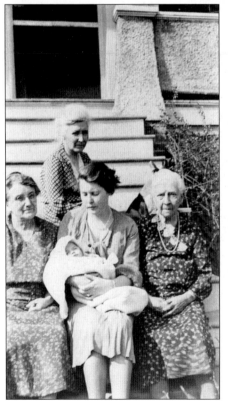

Several Somerset families have lived here for generations, including the Carruthers, Crumps, Jaszis, Krynitskys, Norlings, Schneiders, and the van Hemerts. Four generations of the Carruthers family are shown here on the steps of their Dorset Avenue home in the early 1930s. At this time, the Brown family rented the house that their daughter and her husband would later purchase. Pictured from left to right are grandmother Martina Burch Carruthers, grandmother Harriet Brown, Rachel Carruthers holding baby Barbara, and great-grandmother Mary Nourse Muncaster. (Courtesy Barbara Carruthers Montfort.)

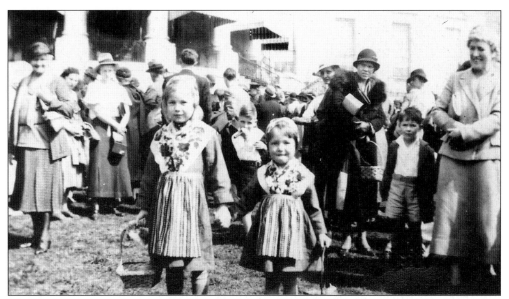

The Norling girls, in the national dress of their Swedish parents, attract attention at the White House Easter Egg Roll. The girls took the trolley car downtown with their mother for this Easter treat. Anne (left) holds Rita's hand; their mother, Elisabeth, is on the far right of the photograph, dressed in a light-colored suit. The public were allowed free range around the White House grounds in the early 1930s. (Courtesy Rita Norling Verkouteren.)

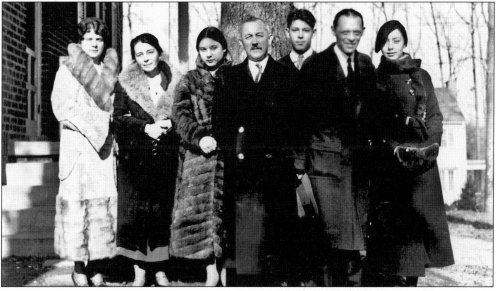

The first of four generations to live in Somerset, Alexander Ivan Krynitsky brought his family to the United States when he was supervising munitions purchases for Russia during World War I. The Russian Revolution overturned the tzar, and the family could not return. When he was working at the bureau of standards in the early 1920s, a friend, Mr. Roberts, told Mr. Krynitsky about "a good piece of land in Somerset you should look at." He bought that land and, in 1933, built a house on it. In December 1934, the Krynitsky family is pictured outside their new home; from left to right, they are unidentified, Helen, Zora, Alexander Ivan and John Krynitsky (at back), and two unidentified relative. (Courtesy the Krynitsky family.)

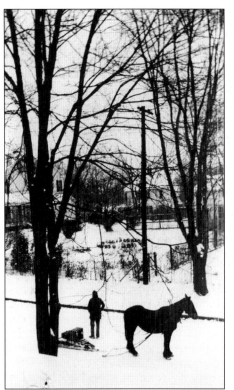

It is the winter of 1933, and Joseph S. Hardy delivers mail on Cumberland Avenue from a horse-drawn sled after a snowstorm. A farmer who lived at the bottom of Dorset Avenue, Mr. Hardy kept pigs, drove a mule wagon, and did odd jobs in Somerset.

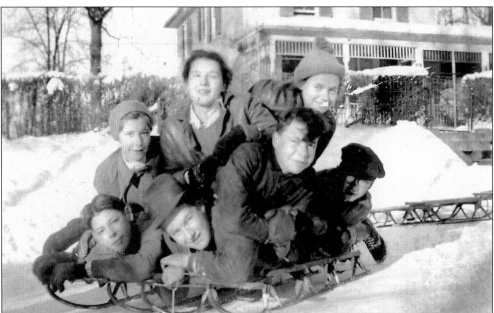

Sledders on Cumberland Avenue in 1935 pack sugar, which involved sledders stacking themselves the way the Sanitary Dairy (later Safeway) would stack sugar sacks: two sacks crosswise atop another two, and so on. Pictured from left to right are the following (first row) John Krynitsky, Walter Palmer, Howard Bryan, and Morton ?; (second row) Helen Bryan, Jane Dunbar, and Louis Watkins. (Courtesy the Krynitsky family.)

A cinder drive ran across town property to the rear access of the Carruthers home when they purchased it. The family called it the black road, as Mr. Carruthers maintained it with cinders from his coal furnace until he changed to an oil furnace when the town took over maintenance of the road. In 1953, Mayor Day began to charge the Carruthers $1 a year rent to use the road. Mr. Carruthers realized that this was to prevent him from laying claim to the land. (Courtesy Barbara Carruthers Montfort.)

Celebrations and holidays were marked with friends and neighbors. Here Somerset children enjoy an Easter picnic with their friends in the front yard of the house at the corner of Surrey Street and Essex Avenue in 1938. Pictured from left to right are Lee Greenburg, unidentified, Joyce ?, Rita Norling (behind), Patty DeCoursey, unidentified, and Mary Ann Linscott. (Courtesy Rita Norling Verkouteren.)

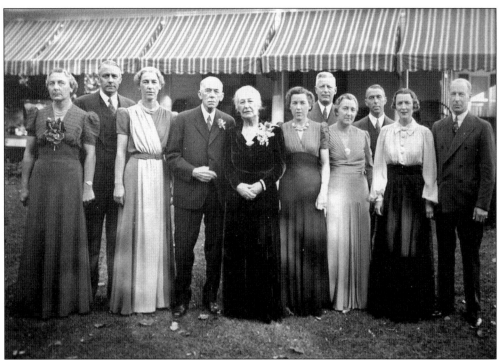

Former Mayor John William Stohlman and his wife, Annie, celebrated their 50th wedding anniversary in their Somerset home in October 1939. Here they pose in the garden surrounded by their nine children. (Courtesy Tom Stohlman.)

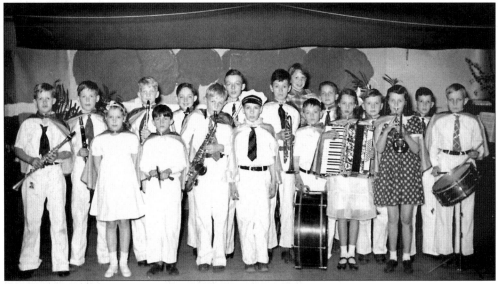

The town's population grew by one quarter between 1930 and 1940, and the school grew with it. Somerset Elementary School Band in 1938 included many Somerset kids and some from close by communities. Among them were, from left to right, (first row) Donald Levitt (clarinet), Malorah Christman, unidentified, Dick Verkouteren (saxophone), unidentified, Donald Gish (trumpet), unidentified, Ernestine Aiken (accordion), unidentified, and Bob Verkouteren, who lived in Drummond (small drum); the second row is unidentified. (Courtesy Rita Norling Verkouteren.)

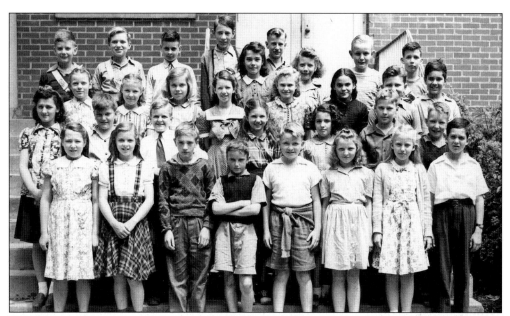

The Somerset Elementary School graduating class of 1940 is, from left to right, as follows: (first row) Rita Norling, Jean van Wagner, Harold DeCoursey, Skip Harrison, Mikey Rogers, Patty Humphries, Jane Cannon, and Jack Conover; (second row) Catherine Seidel, Harold Jackson, Hunter Creech, Pat Morton, Marjorie Sonnemann, unidentified, and Edmund Knight; (third row) Betty Dellett, Malorah Christman, Ellen Turlington, Carol Untiedt, Barbara Dove, Gladys Pugh, Daniel Fendrick, and Wendell Burns; (fourth row) Leon Leonard, Donald Gish, Donald Lasher, Charles Bucy, Renee Simpson, Spencer Stevens, Dona Denton, Dick Verkouteren, and Richard Nagle (Courtesy Rita Norling Verkouteren.)

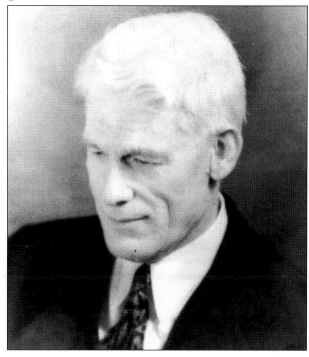

William Horne, elected sixth mayor of Somerset in 1938, completed his two-year term of office in 1940. Mr. Horne had served in the South Carolina Volunteer Infantry during the Spanish-American War and taught at Chester County High School in South Carolina before moving to Somerset in 1912. In addition to his public service with the town, he was an outstanding leader in Montgomery County civic affairs. (Town of Somerset collection; courtesy Mr. and Mrs. Robert Horne.)

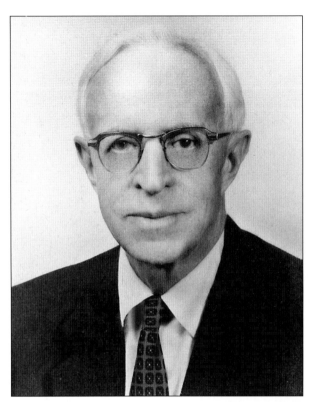

Irving M. Day was elected mayor in 1940. Although often absent from council meetings because of business travel, he served seven terms. Born in Honeyoe, New York, he began selling heating and cooling equipment to large office complexes after graduating from Union College in Schenectady. He and his wife, Doris, moved to their Cumberland Avenue home in 1928. They had three children, Margaret, Irving, and Hartley. Avid theater enthusiasts and amateur actors, the Days helped found the Montgomery Players in 1929. (Town of Somerset collection; courtesy Mrs. Irving Day.)

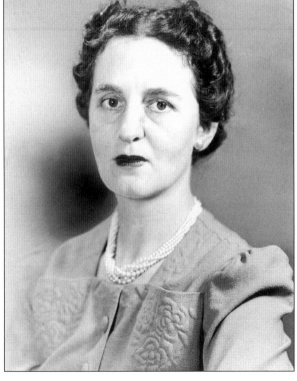

Also elected in 1940, Lou Prentiss Childs, wife of *Saint Louis Post-Dispatch* journalist Marquis Childs, became the second woman to serve on the town council. (Copyright *Washington Post*; reprinted by permission of the D.C. Public Library.)

Four

A TOWN GROWS AND ADDS GREEN SPACE 1941–1968

The war years seemed to have little effect on town business. In 1942, Henry Genus, the town laborer, reported that he would be unable to get to work because of lack of gasoline, and the clerk was instructed to notify the Rationing Board that, "the Council recommends favorable action on Henry Genus' application for additional allotment of gasoline."

Also that year, 50 residents attended a meeting at which a moving picture entitled *Fighting the Fire Bomb* was shown. Council member Lou Childs presented a report on air-raid wardens in the Somerset area and what women could do to assist. A county air-raid warden system was established, and town resident and syndicated columnist Marquis Childs was designated senior sector warden for Somerset and Drummond. Part of the town lot was given over to a victory garden.

In 1944, the council briefly considered adopting an ordinance requiring residents to obtain council approval to sublet or rent rooms in their homes, but the minutes of the town council meeting note that "with the housing authorities in Washington begging everyone who has a spare room or an unoccupied part of his house to take in strangers, even if it has not been his habit in the past" the Council decided against it.

The first inkling of the encroachment of development came in 1943, when owners of the Bergdoll tract petitioned for a zoning change to allow them to build apartments within the town boundaries. The town fought that move vigorously and effectively. The Bergdoll Estate sold off much of its land in three auctions over 1946 and 1947, and plans for new houses in what was to unofficially become known as new Somerset began to appear before the council with increasing frequency.

Then a rezoning application threatened development of a medical clinic with parking for 84 cars at the corner of Dorset and Wisconsin Avenues. It and a similar application for a department store were vigorously opposed. All this was just the run-up to decades of fighting to resist the encroachment of commercial and high-rise apartment development. *Washington Post* columnist, town council member, and later vice president of the council Hobart Rowen later described these years as "a time when the sheer determination of a number of citizens . . . overcame tremendous pressure by developers and their high-priced lawyers that would have transformed

our still-tranquil community into something like the chock-a-block high-rise clutter of today's Friendship Heights."

Through the 1950s and 1960s, the town would fight bitter legal battles that were supported by aggressive community action. It would win time and the 12 acres that now constitute Vinton Park, as well as the land on which the town pool now sits. Indeed, Vinton's prescient actions in winning this space and purchasing other parcels as they became available—often acquiring grants to help purchase them—gave the community the buffer of green space from nearby development that it enjoys today.

In contrast to its fights against encroaching development, the town council otherwise dealt mainly with commonplace issues such as garbage and leaf collection, replacement of dying trees, ever-problematic drainage and flooding, and constant complaints of speeding traffic. In 1957, William Tillman replaced Henry Genus as the town laborer.

The town remained a rural suburb; residents complained of excessive blowing of whistles, especially at night, by engineers on the Baltimore and Ohio (B&O) Railroad while passing Somerset on the site of the present-day Capital Crescent Trail. But development was increasing nearby. Friendship Heights became increasingly visible, as high-rise apartments began to loom above the trees. In 1952, the town's street numbering was changed from three digits to four to match those of the surrounding area. In new Somerset, California-style and split-level homes sprung up on woods and fields that formerly had been the playgrounds of many a Somerset child. The Woman's Club, prodded by the growth of new Somerset (from 1950 to 1960 the town's population grew from 430 to 1,444 residents) pushed for a new town entrance on Greystone Street. Designed by well-known local architect Francis D. Lethbridge, it was completed in late 1965.

The year 1956 saw the 50th birthday of the town's incorporation, and Woman's Club member Dorothy O'Brien wrote an eight-page booklet outlining the town's history. Without her early work, this book would not have been possible.

Despite concerns about the conflict overseas, the early 1940s began calmly. Here the Norling family enjoys afternoon tea in their Essex Avenue garden. Rita Norling remembers that her mother often made club sandwiches on Sundays. When the weather was good, they would eat outside on the green table and chairs. Pictured from left to right are Anne, Elisabeth, Jimmy, Rita, and Victor Norling. (Courtesy Rita Norling Verkouteren.)

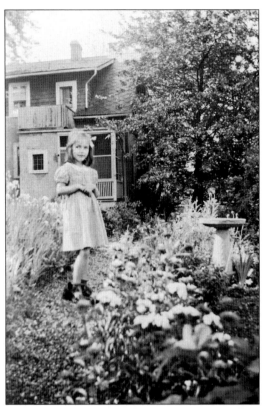

Somerset has always attracted gardeners. Barbara Carruthers, photographed here in 1940 in her mother Rachel's garden, recalls the iris bed behind her on the gravel path that ran through the sunken garden. "All kinds of flowers nestled around the bird bath and along the paths. Mrs. Barnes down the hill had a tall currant bush and a grape arbor (which I loved) and lilies of the valley all along her open side porch. Lovely." (Courtesy Barbara Carruthers Montfort.)

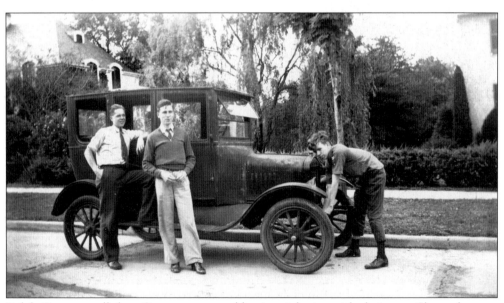

Ralph Crump recalls how Somersetters would enjoy tinkering with their cars. Shown here on Essex Avenue's original concrete pavement are Jim Norling (left), Ed Stohlman (right), and Bob Balcom at the crank of his 1923 Model-T Ford, which he called Zeke. (Courtesy Joan Weiss.)

Tennis had been a big part of the social fabric of Somerset from the early days, when out-of-town amusements were hard to reach. Several residents built tennis courts for the enjoyment of family and neighbors, including this one in the Saylor's back yard, where Z. Leon Saylor would give tennis lessons to Somerset children. Here a young Dick Stohlman stands ready for a game in the early 1940s. (Courtesy Rita Norling Verkouteren.)

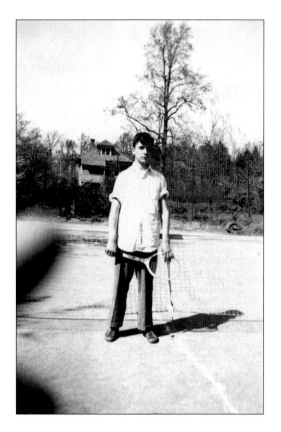

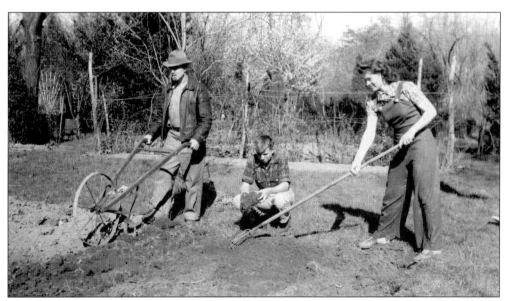

Soon the impact of war was felt. Part of the town lot was given over to residents to plant victory gardens. Individual residents played their parts in the war effort, too. Here Oliver Gish, Donald Gish, and Eleanor Gish Crow prepare a victory garden in their Essex Avenue yard in the spring of 1943. (Courtesy Eleanor Gish Crow.)

Somerset youngsters hung out together. Here the Wolves, with Anne Norling and their Wolfwagon number 1, meet outside the Balcom house on Surrey Street. Pictured from left to right are (first row) Anne Norling, Hugh Frampton, Donald West, and Ed Stohlman; (second row) Jimmy Norling and John Rickey. The Stohlmans' dog, Sport, saunters off toward Dorset Avenue. (Courtesy Rita Norling Verkouteren.)

Barbara Carruthers enjoys the family garden with her baby sister, Patricia, in 1944. "We had a large maple tree in the backyard . . . my father wanted us to play at home so he added a trapeze and a monkey bar with a small swing and each year had a half load of sand dumped under the tree. We stayed home. But it attracted everyone else's children!" (Courtesy Barbara Carruthers Montfort.)

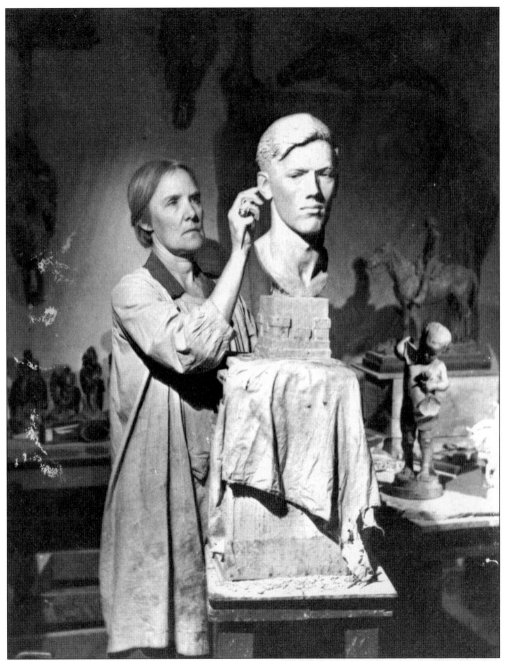

In her studio on Dorset Avenue, internationally acclaimed British sculptress Kathleen Wheeler thinks about her son, who was in Europe with the Army Corps of Engineers, as she sculpts his image (the castle on the base is the corps' insignia). The Crump family (Wheeler kept her maiden name when she married William Crump) moved to Somerset in 1929. One early piece of Wheeler's work, two horses with her sister riding one of them, was seen by Edward VII at the Royal Academy in 1910, at which time he ordered a bronze reproduction of it. It is said to be displayed in one of the royal households. Three generations of the Crump family have lived in Somerset and attended Somerset Elementary School. (Courtesy Donna Harman.)

Edwin and Florence Stohlman and their son, Tom, posed for this photograph in their Essex Avenue yard opposite the open fields and woods of the Bergdoll tract, where Somerset kids spent endless hours. Rita Norling recalls the tepee village she and her friends built there. It was "quite remarkable —it was written up in the newspaper." She recalls cutting Christmas trees from those woods: "They weren't perfect, of course." (Courtesy Joan Weiss.)

Change was on the horizon. *Saint Louis Post-Dispatch* journalist Marquis Childs lived in, and wrote his famous "Washington Calling" column from, Somerset. In 1944, he wrote, "Somerset sums up a great deal of the best that is America. . . . But now there is a proposal to change the nature of this community—rezoning, it is called. No one . . . wants this rezoning. But we have no assurance that this will not happen, regardless of all our protests." (Copyright *Washington Post*; reprinted by permission of the D.C. Public Library.)

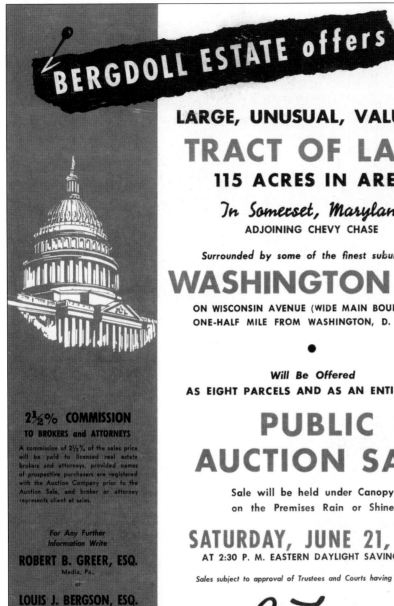

The town was abuzz when posters like this began to appear. There were auctions in January and December 1946 and April 1947 to sell off parcels of the Bergdoll Tract (named after the Philadelphia Bergdoll family that had acquired it in 1885). Of the summer 1947 auction, held under a tent near the Wisconsin and Dorset Avenues entrance to town, Joe O'Brien recalls, "My parents, brother Dick, and I attended and I'm sure every other town resident did as well." His memory serves well, as can be seen from an 8-mm movie film John Brady made of the many residents gathered for the auction.

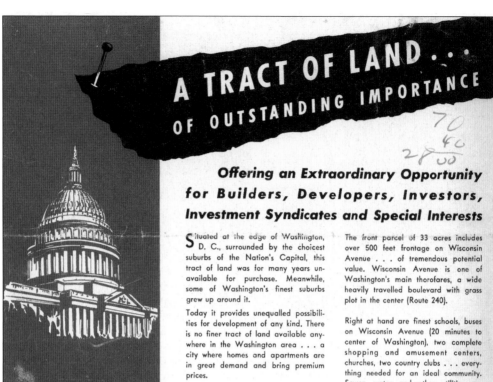

A TRACT OF LAND...
OF OUTSTANDING IMPORTANCE

Offering an Extraordinary Opportunity for Builders, Developers, Investors, Investment Syndicates and Special Interests

Situated at the edge of Washington, D. C., surrounded by the choicest suburbs of the Nation's Capital, this tract of land was for many years unavailable for purchase. Meanwhile, some of Washington's finest suburbs grew up around it.

Today it provides unequalled possibilities for development of any kind. There is no finer tract of land available anywhere in the Washington area . . . a city where homes and apartments are in great demand and bring premium prices.

Rare physical beauty is found here. Gently rolling contours, stately trees and delightful vistas make it ideal for residential development. Graceful, curving, proposed streets have been laid out in conformity with the topography of the land, including a beautiful wide proposed Parkway.

The tract has been preserved unspoiled in its entirety and, as a result, is suitable for a development of any magnitude or character, or for a special purpose. The buyer will be in a position to determine and control its ultimate destiny.

The front parcel of 33 acres includes over 500 feet frontage on Wisconsin Avenue . . . of tremendous potential value. Wisconsin Avenue is one of Washington's main thorofares, a wide heavily travelled boulevard with grass plot in the center (Route 240).

Right at hand are finest schools, buses on Wisconsin Avenue (20 minutes to center of Washington), two complete shopping and amusement centers, churches, two country clubs . . . everything needed for an ideal community. Sewer, water and other utilities are available at the borders of the tract. At the present time the entire tract is zoned for single family dwellings.

The auction sale of this unusual property presents one of the country's outstanding development and investment opportunities. It deserves your most careful attention and study. We urge you to send at once for any other information you may desire, and to inspect the land personally in order to fully understand its extraordinary potential money-making possibilities.

The plan shown on the inside page of this circular illustrates how the tract may be subdivided. This plan has been prepared with the assistance and advice of a recognized expert in community planning and has received the preliminary approval of the Maryland National Capitol Park and Planning Commission, and the town of Somerset, and has been approved as satisfactory for the installation of sewer and water to all lots by the Washington Suburban Sanitary Commission. However, the plan, which has not been recorded, is not binding upon the purchaser.

Sale Will Be Held Under Canopy
ON THE PREMISES RAIN OR SHINE

SATURDAY, JUNE 21, 1947, at 2:30 P. M.
EASTERN DAYLIGHT SAVING TIME

Louis Traiman AUCTION CO. OF PA.

Bankers Securities Bldg., Walnut and Juniper Sts., Philadelphia 7, Pa.—KIngsley 5-2238

The Bergdoll tract had included some 30 acres of woodland with streams meandering through it. Until now it had been *the* place for Somerset youngsters to build a tree house, play at cowboys, wade in the creek, or pick spring flowers. Now it was offered as an "extraordinary opportunity for builders, developers, investors, investment syndicates, and special interests."

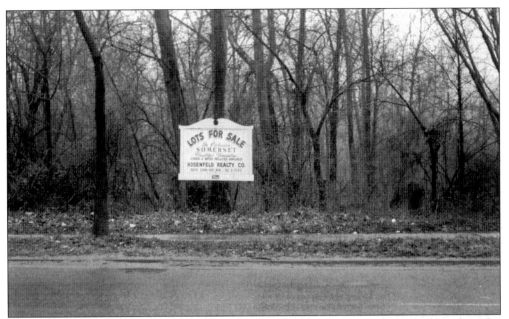

Soon lots-for-sale signs appeared on Wisconsin Avenue. New homes began to sprout. The sale of the Bergdoll tract precipitated decades of fighting to ward off commercial and high-rise development. Indeed, over the years, the town defeated proposals from, among others, a department store and a clinic. In the end, it failed to stop a high-rise apartment complex, although it had a major impact on minimizing the scale and size of the development, as well as its influence on the town.

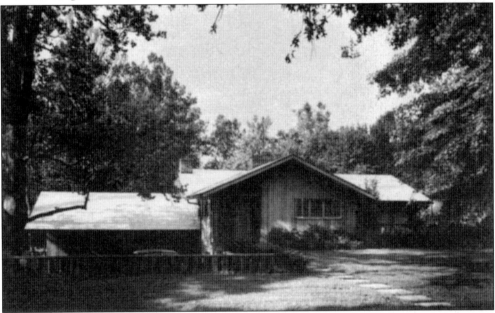

Among the new homes were exciting new architectural designs, such as this house on part of the former Bergdoll Tract. Extremely modern when it was built in 1951, it was designed by award-winning architect and preservationist Grosvenor Chapman, who specialized in residential design. The home was featured in the American Institute of Architects' 1965 *A Guide to the Architecture of Washington D.C.* (Courtesy Robert C. Lautman.)

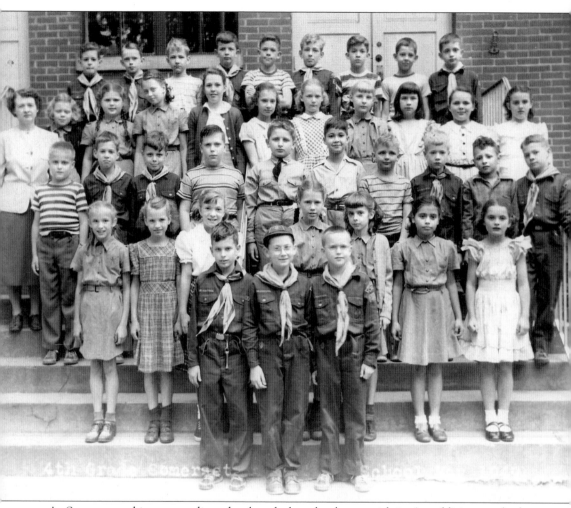

As Somerset and its surroundings developed, the school grew with it. An addition was built in 1949, when this class was in the fourth grade. Pictured from left to right are the following: (first row) Freddy Gaureau, Jimmy Lanning, and Bob Bayer; (second row) Lynn Smith, Andrea ?, Carolyn ?, Adrian Zukert, Annette ?, Gina Gilbert, and Linda Rayma; (third row) Bill Bayer, Julian Weiss, Robert Edwards, Donald Falkirk, Peter Sclavounos, Carlos ?, Peter Clark, Harlan ?, Richard Sachlis, and Wally Atwood; (fourth row) teacher Maude Young, Judy ?, Marcia ?, Katherine ?, Gale ?, Betty Jo Hancock, Shelly ?, Harriet Moore, Donna K. Jamieson, Jean ?, and Lee ?; (fifth row) Chester Humphrey, Herbert Little, Donald Wyneck, Freddy Snell, John Slater, Jimmy Cullers, Paul Eschinger, Howard McCutcheon, and Jerry Trainar.

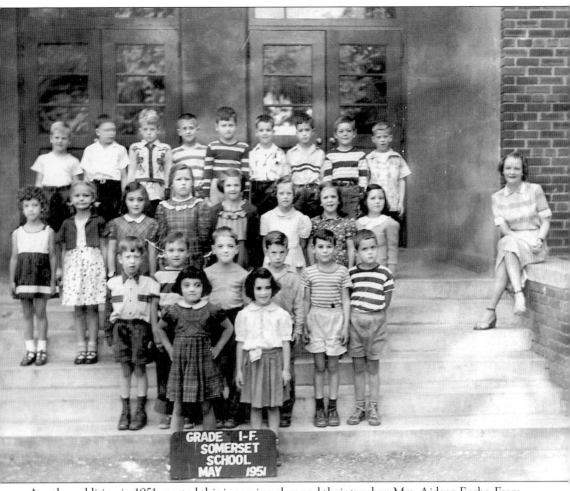

Another addition in 1951 greeted this incoming class and their teacher, Mrs. Aideen Fuchs. From left to right are the following: (first row) unidentified and Margaret Williams; (second row) David Weisbrodt, three unidentified boys, Bobby Hannan, and Jonathan Eric; (third row) unidentified, Marilyn Tanke, unidentified, Corrie van Hemert, Linda McCutcheon, unidentified, Vicki Onslow, and unidentified; (fourth row) Tracy Estabrook, unidentified, Stephen Bossidy, Hank Selke, two unidentified boys, Stephen Lerner, Stephen Goddard, and unidentified

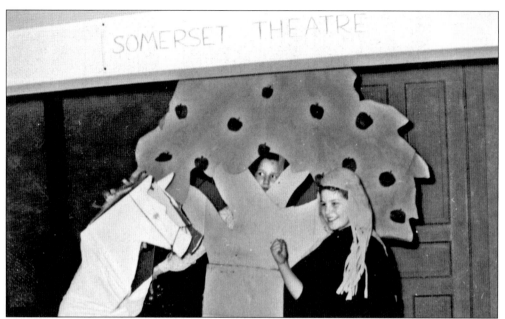

At about this time, Somerset kids started the Somerset Theatre in the basement of Mary and Jay Vinton's house on Cumberland Avenue. They made their own props, costumes, and scenery and performed plays, such as this production of *Little Red Riding Hood*, for their families, neighbors, and friends. From left to right are an unidentified actor as a horse, Joanne Edwards as a tree, and Ronnie Boggart. (Courtesy Corrie Morsey.)

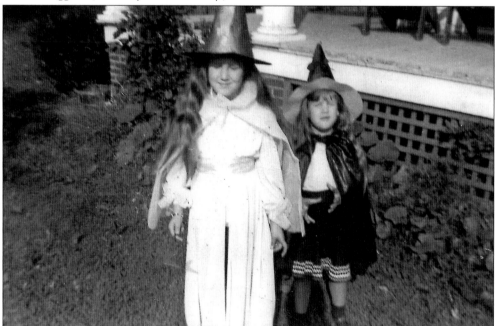

Young Somersetters have enjoyed Halloween trick-or-treating since the town was first settled. Somerset was far smaller when witches Corrie and Anita van Hemert left to trick-or-treat on Halloween night 1950. Half a century later, folks on some Somerset streets might be visited by 300 youngsters or more on Halloween night. (Courtesy Corrie Morsey.)

Journalist Hobart Rowen and his wife, Alice, came to Somerset in 1951. Moving from New York, they were not taken with the Colonial architecture common to the Washington suburbs. They purchased a steeply sloping lot (that they were told was unbuildable) and asked architect Chloethiel Smith to design a home for them. Alice Rowen is photographed in front of the house under construction. (Courtesy Alice Rowen.)

The Rowen family's completed flat-roofed home is nestled comfortably within the natural landscape, affording light-filled views to the woods and creek beyond. Chloethiel Smith became one of America's most successful modern architects. Her contributions to the profession, through design, writing, advocacy, and public service, have since influenced the public debate on urban planning and architecture in Washington, D.C., and throughout the nation. (Courtesy Alice Rowen.)

Throughout the 1950s, the town council, which was accustomed to looking at new home plans a few times a year, suddenly found itself approving plans for many new houses each time it met. As people moved into new Somerset, construction was taking place all around them. This house on Greystone Street, built in 1955 for the Koffsky family, was designed by architect Ken Freeman. (Courtesy Ruth Koffsky.)

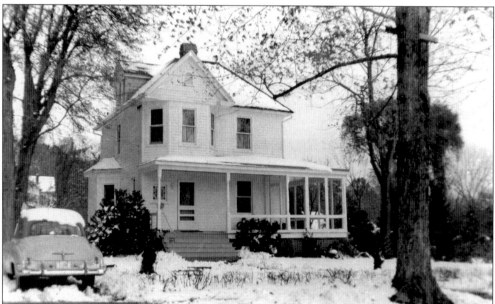

Earlier architectural styles continued to mature alongside the rapid development of new Somerset. Theo and Wilhelmina van Hemert's home on Essex Avenue was built in the early 20th century for James E. Tibbetts, a schoolteacher who came to Washington to work at the government printing office. It was passing its half-century mark when this photograph was taken. (Courtesy Corrie Morsey.)

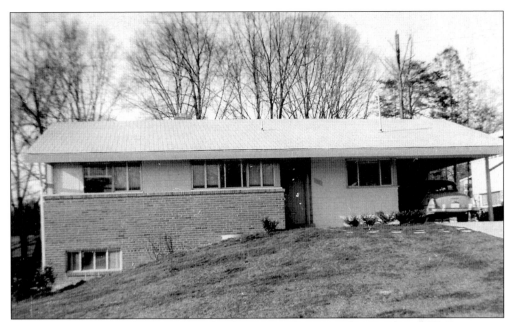

The Gang family home was another of architect Ken Freeman's designs. At age 50, Freeman, a New York clothing designer, changed professions and moved to Montgomery County, where he joined his brother, Carl, in the building business before striking out on his own. Freeman built California contemporary-style bi-level, split-level, and split-foyer houses with simple, tailored, clean lines and lots of glass. (Courtesy Florence Gang.)

Maarten van Hemert loved cowboy TV shows and would spend many happy hours acting out their plots, including perching atop the mailbox at the junction of Surrey Street and Dorset Avenue to protect the U.S. mail from any bad guys that might come along. Over the next few years, the fields in the distance behind Maarten were to begin filling with new homes, as Somerset expanded to keep pace with the fast-growing Washington suburbs. (Courtesy Corrie Morsey.)

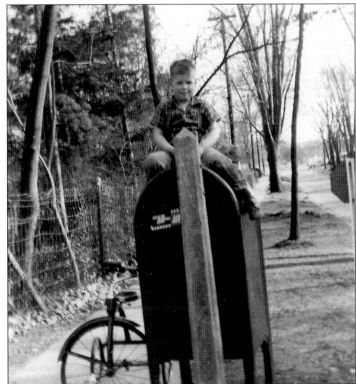

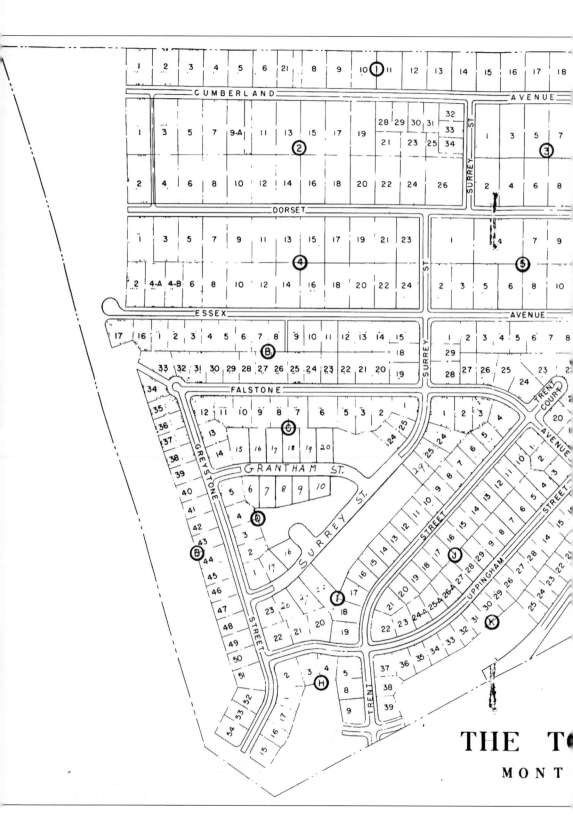

THE T[...]

MONT[...]

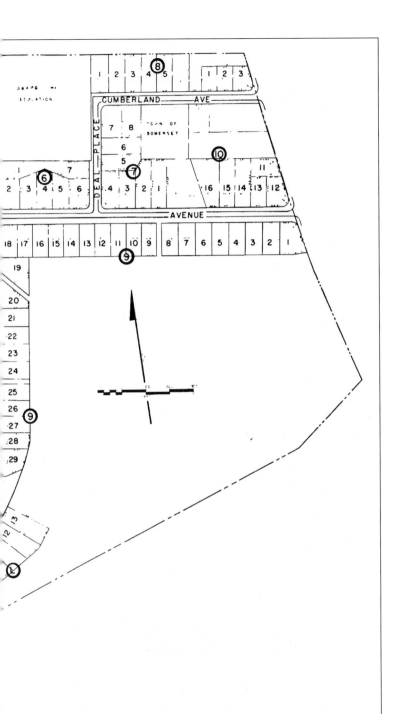

N OF SOMERSET

ERY COUNTY, MARYLAND

This c. 1956 town of Somerset map shows new Somerset street names.

Some things remained the same. Here young sledders Peter Nelson (left) and Alex Krynitsky learn the ropes on Cumberland Avenue in 1954. Alex is the second generation of Krynitsky sledders; the first can be seen in this book's 1935 sugar-packers sledding scene on page 60. (Courtesy Krynitsky family.)

William F. Betts was elected mayor in 1954. Among other initiatives during his two-year term, he appointed a committee to investigate the opportunity for a town facility that would include a garage, office, and meeting room. It was to be 30 years before the town would acquire such a facility. A lifetime career official with the American Association of Railroads, Mr. Betts moved to Somerset in 1949 and was elected to the town council two years later. (Town of Somerset collection; courtesy Mr. and Mrs. William Betts.)

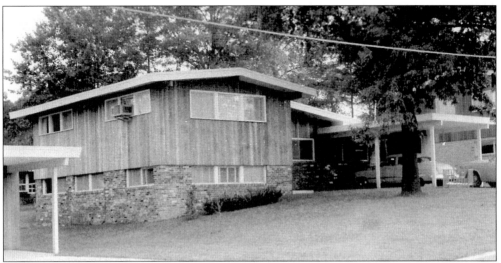

In 1957, the Behr family purchased this Freeman-designed home on Grantham Avenue. Walter Behr was to become very well known not only in town but throughout the county. He served on the town council from 1967 and is the town's longest serving mayor. (Courtesy Walter Behr.)

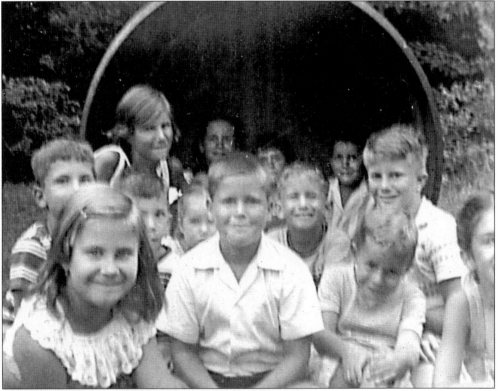

The town had long been connected to water mains by the time this photograph was taken in 1956. Hauled out of an early-20th-century clapboard four-square on Essex Avenue, this huge tank once held water that was pumped into the attic. The tank became known by neighborhood kids as the tin and provided much entertainment, as it was used for climbing, hiding, riding, and, in the summer with its drain hole plugged, swimming. (Courtesy Corrie Morsey.)

Shown here are class teacher Mr. Hutton with sixth grader Corrie van Hemert and school principal Kathryne Bricker on graduation day in 1956. By this time, the school was again bursting at the seams, as the baby boomers continued to enroll. Another addition would be completed in 1958, and Warren Vinton noted that "during these years of growth, Mrs. Bricker and her devoted staff have achieved the very highest standards of elementary public education." (Courtesy Corrie Morsey.)

As the town marked its first half-century since incorporation, Frederick W. Turnbull, a patent attorney in private practice, was elected the ninth mayor. He served just one term, which ended in 1958. A long-standing member of the St. Andrew's Society, he often could be seen and heard playing his bagpipes on the veranda and lawns of his extensive property. (Town of Somerset collection; courtesy Mr. and Mrs. Frederick W. Turnbull.)

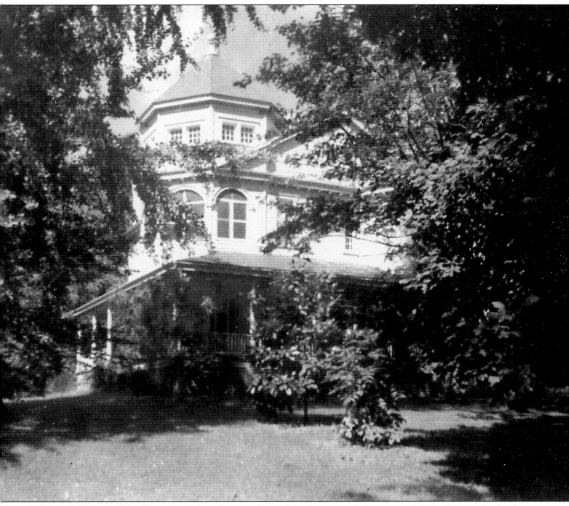

Frederick Turnbull had acquired his Queen Anne Victorian-style home in 1950. Originally built for town founder Miles Fuller, who sold it in 1900, for many years it was rented to the DeCoursey family, who then purchased it in the 1940s. Harold DeCoursey was a Harvard Law School graduate who became a volunteer ambulance driver in World War I. He later practiced law and taught at Georgetown University. While Turnbull lived here, the Somerset Woman's Club would sometimes hold their meetings in the house. One member, Helen Jaszi, recalls that, "the living room floor sagged frighteningly." Turnbull sold the house in the mid-1960s to a developer; it was torn down and replaced by three new homes that still exist. (Courtesy Somerset community collection, MCHS.)

In late 1955, the Woman's Club asked Mrs. Joseph (Dorothy) O'Brien, pictured here, for suggestions as to what the club could do "in commemoration of the 50th anniversary of the passing of the enabling act of Somerset." She suggested the club be responsible for preparing a town history. She got council approval, researched and wrote the text, and had an eight-page brochure printed and mailed to every town resident—all in less than six months. (Copyright *Washington Post*; reprinted by permission of the Washington, D.C., Public Library.)

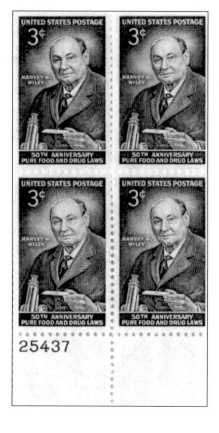

Coincidentally, at the same time that the town recognized its 50th birthday, the postal service issued this commemorative 3¢ stamp to recognize the 50th anniversary of the Pure Food and Drug Laws. The stamp featured Somerset investor and founder Dr. Harvey W. Wiley, who was instrumental in the passage of the Pure Food and Drug Act, which began an era of consumer protection.

In 1956, a first-class stamp cost 3¢, and to cool off with homemade lemonade on a hot summer's day cost 5¢. These young entrepreneurs on Essex Avenue are, from left to right, Christine, Maarten and Corrie van Hemert. Their father, Theo, is coming out of the front door onto the porch. (Courtesy Corrie Morsey.)

Warren J. Vinton served as mayor from 1958 to 1969. A former assistant commissioner of the Public Housing Administration, he led the town through countless fights against encroaching development, as well as many positive advances in the town's growth. Active in zoning and land-use issues, he was responsible for acquiring much of the town's parkland. Vinton Park, which buffers the town from the Somerset House apartment towers, was named in his honor. (Town of Somerset collection; courtesy Mrs. Warren Jay Vinton.)

In 1958, Somerset resident Arthur Ringland was honored by the United Nations for his role in founding CARE. In 1938, he and his wife, Dorothy, purchased the Wiley House; they lived in Somerset for 40 years. From 1900 until 1945, Arthur Ringland worked for government programs ranging from conservation (he helped establish the national park and forest systems) to refugee relief. In 1945, he originated the concept of the private voluntary organization that became CARE. (Courtesy Truman Presidential Library.)

Old Somerset continued to flourish alongside the growing new Somerset. Pictured here about 1960, when it was owned by Theo and Wilhelmina van Hemert, is the house that dentist Dr. Zenas Alderman and his wife, Ettie, built around 1906. Known only as Washington, a well-known figure around town in the 1960s is walking in front of the house; he was a caretaker and cook for John and Mary Brady next door. (Courtesy Corrie Morsey.)

Mr. Watkins, a chemist with the Pure Food and Drug Administration, bought this 1906 home next door to his boss, Dr. Paul Dunbar, in the 1920s. President of the American Iris Society, Watkins kept an iris garden, which took up the entire east-side lot (now occupied by a red brick house). Wilhelmina van Hemert and her brother-in-law, Col. Wim van Hemert, stand in front of the house in this c. 1960 photograph. (Courtesy Corrie Morsey.)

As new Somerset grew, members of the Woman's Club once again moved into action, this time to beautify the entrance to the new part of town. They began by rolling up their sleeves and planting trees and bulbs at the intersection of Greystone Street and River Road. Pictured from left to right are unknown, Alice Grochel, Helene O'Neil, Liz Champlin (child), Trudy Becker, and Alice Champlin. (Courtesy Alice Champlin.)

In 1963, the Woman's Club approached the town council with an offer: $500 toward the cost of appropriate entrance gates. Charles. M. Goodman and Francis D. Lethbridge, two up-and-coming modern architects, were asked to submit plans. The Lethbridge plan was selected, but all was not well. By mid-1966, the globes had to be replaced "with something that may be less of a target for boys to shoot at," according to the minutes of the town council. Indestructible globes were identified and hailed a success when they remained intact throughout Halloween night. (Courtesy Florence Gang.)

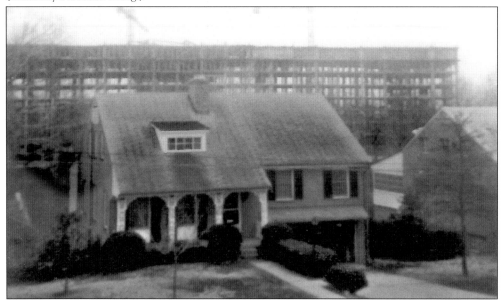

Meanwhile, high-rise apartment blocks were taking the place of modest turn-of-the-century clapboard homes in nearby Friendship Heights. The Irene, pictured here under construction, was several hundred yards away from new Somerset and buffered by the creek and parkland. As the 17-story apartment block began to rise behind Uppingham Street in the winter of 1966, residents of new Somerset christened it the Chinese Wall. (Courtesy Virginia Mitz.)

Five

A Genteel Town Gets Up to Fight
1969–1986

As chapter five opens, the town had some 1,300 residents within its borders, and its genteel ways continued, at least on the exterior. The opening of a swimming pool in 1971 gave Somersetters a greater sense of community, as its cool waters brought residents of all ages together to enjoy hot summer days. The pool gave birth to the Somerset Dolphins swim team, which was to become a highly successful competitor in the county league and the pride of the town.

Undeveloped lots purchased by the town, often with the help of state open-space grants, now provided buffers between the rapid high-rise development in nearby Friendship Heights as well as space for kids to play and nature to abound. July Fourth still saw residents picnicking together, Halloween brought kids out trick-or-treating, the snow brought them to Cumberland Avenue to sled, and, for the children who studied there and their parents, the school continued to be the heart of the community.

Despite the growing population and increased service provision, Somerset still had no town hall. Meetings of the town council took place sometimes at the Perpetual Building Auditorium in Bethesda, sometimes at the Somerset Elementary School, sometimes on the second floor of the swimming pool bathhouse, and, on some occasions, at the Chevy Chase Village meeting room. Some meetings attracted considerable numbers. For example, when the State Highway Administration proposed to expand River Road, 175 residents of Somerset and nearby streets convened. (That fight was won by the residents, and the road was not expanded.) Space for town staff and an administrative center were becoming increasingly necessary. Mayor Warren Vinton had purchased the Red House in 1965, earning a grant under the Federal Green Space Program to fund it. Rented to a school for autistic children for some years, the town began to use it for office space, and, on July 4, 1982, it was dedicated as Somerset's town hall.

Beautification efforts continued with the Woman's Club offering some $300 toward plantings to beautify the pool area if the town were to match it. The council agreed, but as had been the pattern with the Woman's Club initiatives over the years, by the time the landscaping was complete, the total costs were some 10 times the amount of the club's donation, most of which was paid by the town. The Somerset Garden Club, under Pres. Eleanor Weinstein, began working on

a census of the town's more than 700 trees, which included the location, species, size, condition of tree, and growing space.

But amid this genteel exterior, tumultuous events were rocking the town as loudly as the explosions that were heard and felt up to 10 o'clock at night as Metro blasted a tunnel for the red line. The early 1970s saw the town and its elected officials facing a number of lawsuits, including several from the Dorset Corporation and another for $10,000 damages for injuries sustained by a child while playing with a tennis net mechanism. The courts ruled in favor of the town in all cases, but the town incurred considerable legal costs over a number of years as the cases dragged on, which also consumed many long hours of the town's elected officials' time.

Development of part of the Bergdoll Tract by its owners, Community Builders, was in contention throughout this period, as it had been on and off for more than 20 years. As the 1980s were drawing to a close, the builders tried to get approval for three 26-story buildings.

A citizens association founded in 1973 provided leadership and manpower to deal with many planning issues that might potentially impact the town. More than 150 members actively participated in the association's heyday when, through diligent efforts, it helped defeat many proposals, including one to widen Dorset Avenue and another to develop a major commercial/office/apartment complex on the Community Somerset property. The association also participated with other local municipalities to downzone the Friendship Heights Central Business District (which was contested all the way to the Supreme Court). Bill Spitzer, chair of the association, wrote in 1981, "Continuous, active citizen involvement has contributed significantly to maintaining the town's character."

James Capello, longtime Somerset clerk-treasurer, suffered a mild stroke and resigned after 36 years of service. Capello Park was named in his honor. Sadly, Mayor Goldberg died in office in 1976. Council vice president Walter Behr finished the unexpired term, was subsequently elected, and went on to become the longest-serving mayor in Somerset history, serving from 1976 to 1982 and then again from 1986 until the time of writing.

Jerald F. Goldberg, a certified public accountant and decorated World War II veteran, was elected the town's 11th mayor in 1969. He had been on the town council since 1962. Throughout his terms of office, both on the council and as mayor, the town's elected officials fought developers and faced lawsuits, including several from the Dorset Corporation regarding acquisition of three parcels of land. Mayor Goldberg passed away in office in 1975 at 52 years of age. (Town of Somerset collection; courtesy Mrs. Jerald Goldberg.)

William Smith recalls swimming in Little Falls Creek in the 1920s and 1930s. By 1971, a new town pool provided a cleaner, safer swimming environment for Somerset kids. From left to right, George Jaszi (known for inventing the concept of Gross Domestic Product [GDP]) and his wife, Helen (an economist, council member, active PTA member, and town historian), chat with Mayor Jerald Goldberg (who, with Mayor Vinton, was instrumental in acquiring the land for the pool and later oversaw its construction) at the pool opening. (Courtesy Town of Somerset.)

From the start, the pool was the center of the community in the summer. Here A. Eugene Miller and neighbor Virginia Mitz share a joke at the pool in 1974. Eugene Miller served as both a council member and the mayor. Virginia Mitz was elected to the town council in 1982 and has served for many years as the town's representative to the Citizens' Coordinating Committee for Friendship Heights. (Courtesy Virginia Mitz.)

On June 6, 1976, the town held a ceremony and installed a plaque in the late Mayor Goldberg's memory at the pool he had helped to acquire and build. Pictured from left to right are the following: (first row) Gail Schwartz and Jesse Weinstein; (second row) Louise Behr, Zola Schneider, Barbara Rodbell, and Joe Barse; (third row) Helen Jaszi, Irving Schneider, Walter Behr, Philana Weiss, and Juliet Weiss; (fourth row) Peter Schneider, Joan Weiss, and Eleanor Weinstein. (Courtesy Joan Weiss.)

That same year, the town council voted to support a swim-team program and authorized $950 for the purchase of pool equipment. The team was admitted to the Montgomery County Swim League's J-Division, and a student art project produced this flyer, which was mailed with the town *Journal*, to solicit team members.

Boys and Girls Ages 6 thru 18

LOOKING FOR A SUMMER ACTIVITY?

SUMMER IN SOMERSET

Join the 1976 Somerset Swim Team

- **Daily Practice at the Somerset Pool**
- **Weekly Meets at pools of the Montgomery County Swim League's "J" Division**

Good Times *New Friends*

Good Training *New Skills*

The Somerset Swim Team is open to all swimmers whose families pay 1976 pool user fees.

No swim team experience is necessary.

Watch the pool bulletin board for practice schedule.

For further information, call Corrinne Swoff, 656-5892, or Mary Lou Terselic, 656-6074.

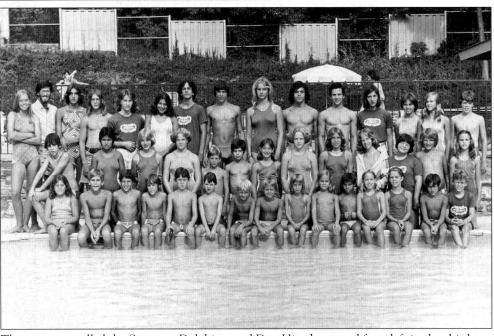

The team was called the Somerset Dolphins, and Dan Hirsch, second from left in the third row in this 1977 team photo, was its coach. Dan brought in the uniforms and the cheers that are still used today. (Courtesy Tracy Truman.)

James J. Capello had served as town clerk-treasurer from 1940 until 1960, when he fell ill and had to resign. He set a record not only for longevity, but also for efficiency, capacity for detail, and selfless devotion to the interests of the town. He earned $25 per month when he first took on the job. (Town of Somerset collection.)

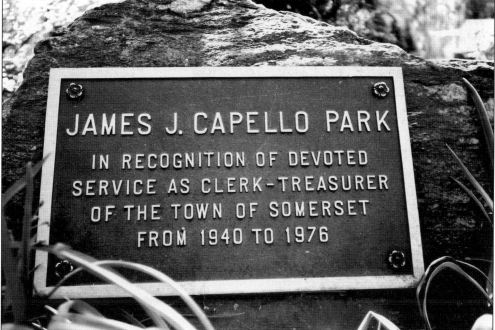

JAMES J. CAPELLO PARK
IN RECOGNITION OF DEVOTED
SERVICE AS CLERK-TREASURER
OF THE TOWN OF SOMERSET
FROM 1940 TO 1976

On his retirement, the town honored James Capello's extraordinary service by immediately designating the small tract formerly known as Cumberland Park, which lies beside the town hall, as Capello Park. This plaque was installed shortly thereafter. (Courtesy Lesley Anne Simmons.)

Walter Behr was elected to the town council in May 1967 and served several terms as vice president to the council until the untimely death of Mayor Jerald Goldberg in 1975, when he filled the late mayor's unexpired term. When that term ended on May 3, 1976, Walter Behr was elected mayor by town residents. Like his predecessors, he led the fight against developers and, in the process, won more open space and parkland for the town. (Courtesy Town of Somerset.)

The town was designated a Bicentennial Community by the Maryland Bicentennial Commission in 1976. At a Somerset Elementary School bicentennial celebration, many of the people featured earlier in this book held a reunion. From left to right are (first row) Margaret Saylor, Lois Cremins, and Joan Weiss; (second row) Beatrice Orfield, unidentified, and Edna Miller Gish; (third row) Oliver Gish and Z. Leon Saylor (Courtesy Joan Weiss.)

Town historian Dorothy O'Brien continued her 1956 historical work, researching titles of original houses, biographies, and photographs of first families and town mayors and collecting documents, including the original papers of incorporation of the Somerset Heights Water Colony and early tax records. She deposited the collection in the County Historical Society Library in 1977. That year, she and Helen Jaszi authored an updated town history, which was published in the *Montgomery County Story Series*.

CAROL STUART WATSON

The Beall-Dawson House, c. 1815
home of the Montgomery County Historical Society
103 W. Montgomery Ave., Rockville, Maryland

THE MONTGOMERY COUNTY STORY
Published by the Montgomery County Historical Society

Judge Thomas H. Anderson, Sr. *President*		Mary Charlotte Crook *Editor*
Vol. 20	May 1977	No. 2

THE TOWN OF SOMERSET
by Dorothy O'Brien and Helen H. Jaszi

In the shadow of the high-rise apartments and the busy commercial establishments along Wisconsin Avenue just north of the District Line lies the Town of Somerset. Because of the continuing concern of its residents for preserving their way of life, Somerset, founded in 1890 by five government scientists, remains today the tranquil community envisioned by its founders.

The land which comprises the Town of Somerset was originally part of the "Friendship" tract containing 3124 acres, which was patented in 1711 by the fourth Lord Baltimore to Colonel Thomas Addison and James Stoddart.[2] This patent was

1. T.H.S. Boyd, The History of Montgomery County, Maryland, from Its Earliest Settlement in 1650 to 1879 (Baltimore, Maryland: Regional Publishing Company, 1968), p. 32.

Dorothy O'Brien's histories described Somerset's government and elections. Elections are held each spring, with the mayor and two council members elected in even-numbered years and the three additional council members in odd-numbered years. Frank R. Garfield, shown here on the porch of his Warwick Place home with the ballot box and registry books in 1977, served as chairman of the board of supervisors of elections from 1966 to 1977. (Somerset community collection, MCHS; courtesy Marjorie Garfield.)

Through the years, the school continued to grow to meet the needs of the increasing number of families moving to the area. The original 1928 structure was long demolished by the time this photograph was taken in 1976, and three additions, dating from 1949, 1951, and 1958, accommodated facilities such as an all-purpose room, library-media center, and spacious music room. (Town of Somerset collection; courtesy Matthew Scheiner.)

1928 building, South Entrance — Courtesy Mrs. Kathryne M. Bricker

SOMERSET
SCHOOL
1928-1978

The school has always been a centerpiece of the community. A 1976 PTA newsletter saluted 93 parents/supporters who gave 3,038 hours to the school's enrichment programs, including help in language and math, fun fund-raisers, and a lovely school garden. The multicultural program with Rock Creek Forest supported integration in celebrating many rich cultures. In 1977, the school welcomed 81 students from 26 countries, and the 50th-anniversary brochure proudly noted that pupils spoke Chinese, French, German, Hebrew, Hungarian, Italian, Korean, Persian, Portuguese, Russian, Spanish, Swahili, and Swedish.

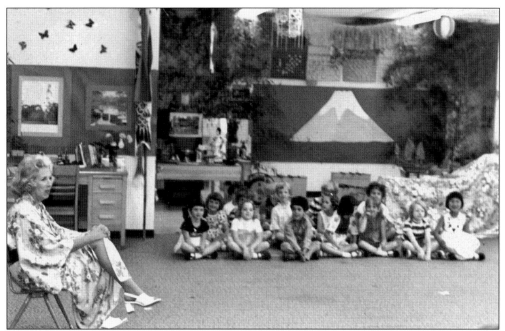

The school's multicultural character was reflected in its activities. Here Mrs. Burtner, dressed in a Japanese kimono with Mount Fuji in the background, teaches kindergartners Japanese. Tracy Truman recalls her children taking part in the Japanese program that Mrs. Burtner put on every spring. (Courtesy Tracy Truman.)

In 1978, Mayor Walter Behr had been elected to serve a second term as mayor when, with his daughter Meg at his side, he led the traditional July Fourth parade down Somerset's lush, tree-lined streets to the swimming pool. He was followed by the marching band and bicycles patriotically decorated by the town's children for the occasion. (Courtesy Walter Behr.)

Trees have always been highly valued in Somerset. The 1890 *Washington Evening Star* report of the founders' land purchase noted they "planned a broad avenue . . . which they would plant with shade trees." Town founder Charles Crampton planted many trees, including two glorious copper beeches; one pictured here stood at the edge of his lot for decades. (Town of Somerset collection; courtesy Matthew Scheiner.)

When Alan Pollin purchased part of that lot in 1978, he generously donated the beech trees and the strip of land on which they stood to the town. In 1988, they succumbed to disease. At the urging of town historian Joan Weiss, a new beech tree was planted in 1989 on the same spot. It was dedicated to the town's fifth mayor, John W. Stohlman, on Arbor Day, 2000.

A tree ordinance requires that residents request permission before cutting down any tree with a trunk of 4 inches or more in diameter, thus ensuring the environmental and aesthetic benefits that trees provide. The town was first recognized by the National Arbor Foundation as a Tree City, U.S.A., in 1982 and continues to hold that designation. (Courtesy James M. Boughton.)

A popular 1980 house tour and tea was held to benefit the town's Red House. Town historian Dorothy O'Brien wrote, "There were huge crowds throughout the afternoon. Miss Helen Stohlman, born early in this century in the family home . . . revisited her birthplace together with five other members of this distinguished family. Mrs. Carl Crampton, widow of the first baby born in Somerset Heights and daughter-in-law of our first mayor . . . also was a visitor."

On July 4, 1982, the Red House was dedicated as Somerset's town hall (housing an administrative office only). Mayor Vinton had convinced the owners of the 1902 house to sell it to the town in 1965 for the sum of $25,000. He had, that same year, purchased the lot adjoining the house (now Capello Park) with a Federal Green Space Grant. For a while, the town leased the Red House to the American Foundation for Autistic Children for use as a training center. (Courtesy Katherine Kosin.)

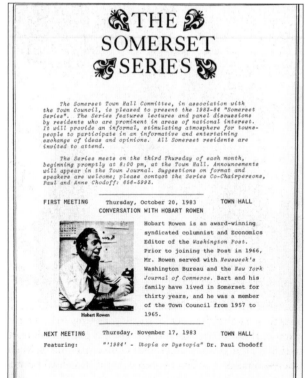

It didn't take Somersetters long to make use of their new facility. In late 1983, The Somerset Series was launched. A promotional flyer boasted that it featured lectures, and panel discussions by residents "who are prominent in areas of national interest" was initiated. Longtime town resident, council member, and award-winning journalist Hobart Rowen was the first featured speaker.

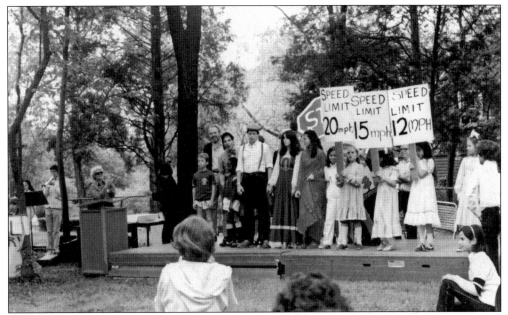

In 1981, the town celebrated its diamond jubilee with a new history pamphlet and several celebrations. These included a play written by Helen Jaszi and performed on the town hall grounds. A narrator, speaking the part of town clerk Capello, told stories about the town's history, which children acted out. Here the enduring problem of traffic and speeding is depicted with speed limits through the years and a stop sign. (Courtesy Joan Weiss.)

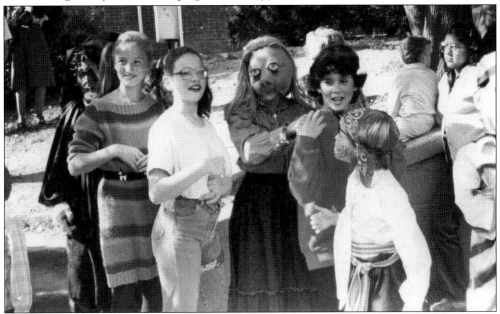

An era's culture is reflected in the costumes Somerset's kids select for trick-or-treating. In Somerset Elementary School's 1982 Halloween parade, the punk rocker movement and popular Muppet TV show were featured with, from left to right, Tina Truman and Kendra Lubaun as punks, Maia Bloomfield as Miss Piggy, Susanne Seckler as a punk, and Sara Landfield as a (timeless) pirate. (Courtesy Tracy Truman.)

A. Eugene Miller served on the town council for seven years before he was elected mayor in 1982; he served two terms until 1986. An avid environmentalist, he led the fight to preserve town parkland and Little Falls Branch, in particular bringing the lawsuit that required Metro to clean up large quantities of oil that had spilled from the Metro bus garage in Friendship Heights in the 1980s.

Meanwhile, 13-year-old Eagle Scout Sam Lasky conceived of and built an 800-foot-long nature trail in Vinton Park with the help of fellow Boy Scouts in Chevy Chase Troop 52. A ribbon-cutting ceremony took place on Arbor Day in 1983 in the presence of county executive Charles Gilchrist, Somerset mayor Eugene Miller, town officials, and neighbors. The trail was dedicated to longtime town resident and environmentalist Arthur Ringland. (Town of Somerset collection.)

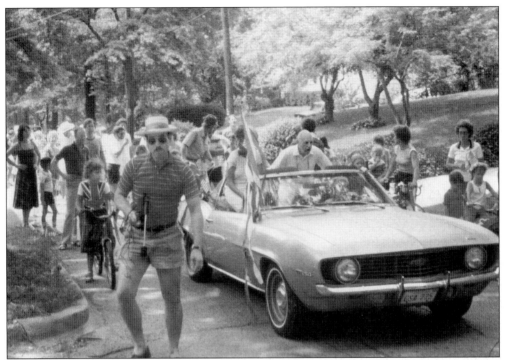

Mayor Eugene Miller continued Somerset's July Fourth tradition by leading the parade to the pool. In 1984, he chose to do so in an open car. (Courtesy Tracy Truman.)

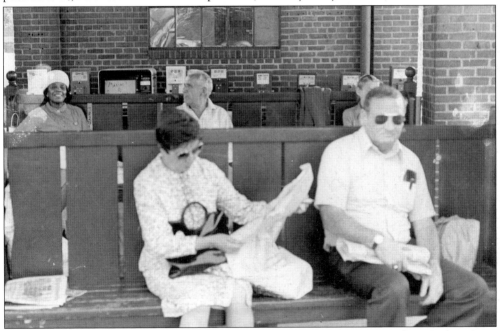

Methods of getting to and from Somerset were about to change. Here resident Arthur Gang (middle, back row) waits for a bus at the Friendship Heights bus terminal, just a short walk from Somerset. Like the trolley terminal before it, the bus station is now gone, although buses still serve the Friendship Heights area. (Courtesy Florence Gang.)

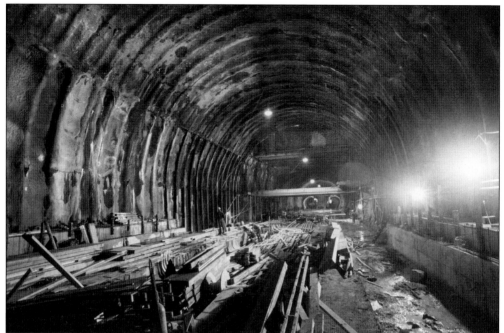

Meanwhile, deep under ground, workers were constructing a 6.81-mile segment of the Washington Metropolitan Area Transit Authority's red line, which was to make downtown Washington, D.C., within far easier—and faster—reach than either the bus or the trolley-car before it. (Courtesy Washington Metropolitan Area Transit Authority [WMATA].)

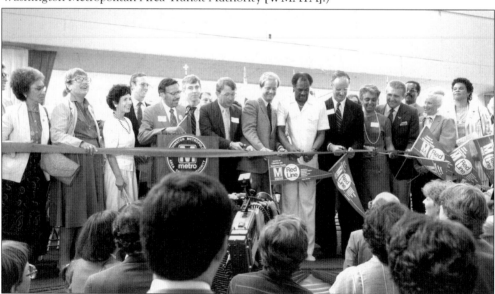

The Friendship Heights Metro train station opening ceremony, in August 1984, was attended by local District of Columbia, Maryland, and Montgomery County dignitaries. From left to right are Hon. Hilda Mason, Hon. Esther Gelman, Rep. Connie Morella, Scott Foster, Rev Jerry Moore, unknown, John Miliken, Ralph Stanley, Mayor Marion Barry, county executive Charlie Gilchrist, WMATA general manager Carmen Turner, Sen. Frank Shore, Horace Jones, Maryland state delegate Ida Ruben, and Hon. Charlene D. Jarvis. (Courtesy WMATA.)

Six

THE TOWN SHRINKS, DISASTERS HIT, THE CHARM REMAINS
1986–2006

As chapter six opens, the first of three condominium towers was under construction on the former Bergdoll Tract, culminating three decades of struggle, often of a litigious nature, over the disposition of that parcel of land. In a record turnout, Somerset voters decided on March 21, 1988, to shrink its borders and de-annex the property. The Somerset De-annexation Initiative (SDI) had a huge impact on this outcome: it raised funds, hired an attorney, educated citizens, and acquired the legal number of signatures to sponsor a referendum—while the developer hired a public relations firm to try to win citizens over. Fay Cohen later wrote, "Finally, the tail wagged the dog into action. A citizen-activated grass-roots movement (SDI) had legally and convincingly preserved the security of the town of Somerset for future generations. In this case—smaller is better!"

Eight years later, ground was broken for construction of the third and last of the high-rise condominiums.

Somerset's largest-ever public works project was completed in 1989. The storm drain system was improved, streets were paved, handicap ramps were installed, and sidewalks and curbs were repaired. To address the perennial problem of speeding, speed humps were put into place.

A storm on Flag Day in 1989 toppled hundreds of trees, damaging dozens of homes and knocking out power for six days in some cases. A 1999 winter storm left Somersetters in the freezing cold without power for three to four days. In September 2003, the remnants of Hurricane Isabel deprived the town of power again for several days.

A new town code adopted in 1989 was the first recodification since 1920. The code no longer carries articles regarding hogs, cattle, chicken, ashes, and privies but has added new ones pertaining to such things as the town hall, speed humps, swimming pool, tennis courts, recycling, and cable television.

In 1990, 54 homes within Old Somerset were officially designated as a Montgomery County Historic District. Thirty-one of them, built before 1915, are considered primary resources. This

does not mean that homes in the district may never be changed, but that the streetscape is maintained with special care and attention paid to ensuring houses are preserved rather than demolished, and that modifications, renovations, and additions are appropriate.

A 1986 addition to the town hall provided meeting space, but as the town entered the new millennium, the building was showing signs of structural defects and was no longer adequate for the town's administration and meeting needs. A town hall renovation committee made what turned out to be a controversial recommendation to substantially renovate or rebuild the facility.

In 1997, the annual pool membership fee was eliminated at a cost of some $45,000 per year in income. Pool use flourished and the swim team with it. A pool heater was purchased the next year. A water slide was installed and a picnic area was created (for which the town won a 13th-annual "Keep Montgomery County Beautiful" award). The energetic swimming pool committee added more and more events to the town's social calendar, including the first of what was to become an annual dog swim on the last day of pool season.

Somerset School was the top elementary school in Montgomery County in 1997 and again in 1998. A tally of its students revealed its continued international character: more than one-quarter—121 children—represented 45 foreign countries. Modular classrooms were added in the 1990s, and in 2003, the old building was demolished to make space for a larger, more modern structure with up-to-date facilities.

Some things were new: the town got its own flag, began to administer annual flu shots, set up a Y2K committee, which adopted an "optimistic but cautious and be prepared outlook," led in recycling efforts, attempted to initiate a neighborhood watch network, and set up a website (www. townofsomerset.com). Some things were not so new: a 1993 committee examined street and traffic safety conditions, noting "flagrant disregard for speed limits, stop signs, and slowdown devices."

Washingtonian Magazine author Diane Granat summed it up in her 1993 "Great Neighborhoods" article: "Somerset preserves a village flavor and a child-centered spirit. . . . While the town government is a focal point for Somerset's citizen activities, what really pulls the community together are school and pool."

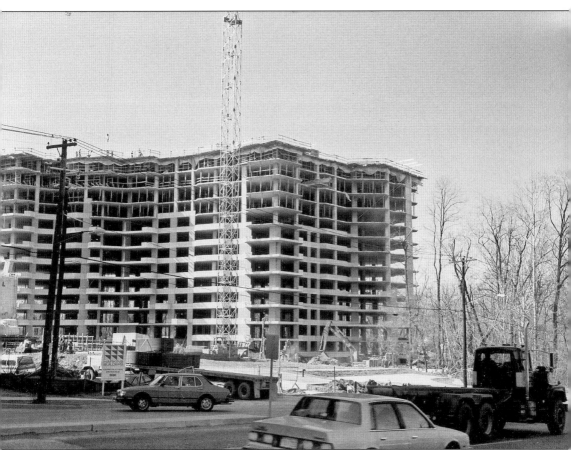

Shown here is the first of three luxury high-rise apartments on the Bergdoll Tract. Their development was stalled nearly a decade, as the town mounted three separate appeals to the Montgomery County Circuit Court. In 1988, the town de-annexed the 18 acres on which the apartments would stand, foregoing significant tax income but ensuring that the priorities of single-family home-owners would not be compromised by those of the apartment residents. (Courtesy Zola Schneider.)

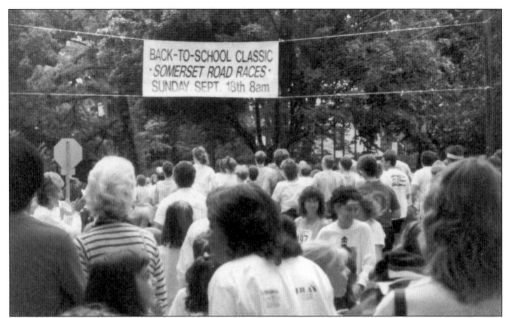

A new way to enjoy the town's streets began with the first Somerset Elementary School Back-to-School Classic 8K race in 1988. The Classic has since become enormously popular with people both in and out of town. The race helps raise funds for educational opportunities: library and classroom resources, technology equipment, cultural arts programs, and extracurricular activities and clubs. (Courtesy Tracy Truman.)

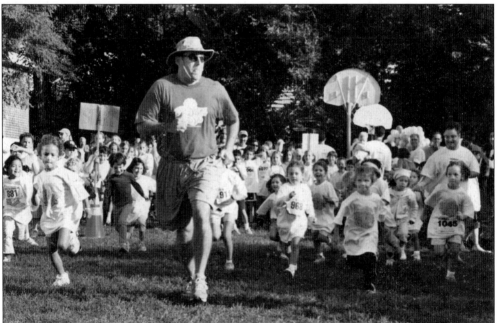

By 2002, the Classic included 2k and 8k runs as well as a "fun run" for the very young, pictured here. The Washington Running Report described it as "another delightful event hosted by the families of Somerset! They have a successful formula for fun at a young age which helps to encourage exercise later in life." (Courtesy M'Liss Reingruber.)

On Flag Day in 1989, a storm so unusual and powerful that it was reported in the *New York Times* hit Somerset. Cumberland Avenue looked like a war zone with several houses severely damaged. One of the two homes on Cumberland that was rendered totally uninhabitable belonged to the Wurtz family after two of the 150-year-old oak trees from Sue Prindle's property next door came through the Wurtzes' roof. Many other families in town had severe damage to their homes and yards. (Courtesy Emily Wurtz.)

Bob Wurtz is shown here in front of some of the debris from the eight trees that fell on his property. His wife, Emily, recalls Bob being interviewed on NBC news, where he was introduced as a storm victim. He played the role well; she says "he looked very victimized!" (Courtesy Emily Wurtz.)

Somerset's historic district was designated by the county in July 1990. Many homes in the historic district, including those on the 5700 and 5800 blocks of Warwick Place and Surrey Street, the 4700 and 4800 blocks of Dorset Avenue and Cumberland Avenue, and on the north side of the 4700 block of Essex Avenue, display plaques like this, indicating they are historic properties. (Courtesy Katherine Kosin.)

Two of the town's oldest-surviving houses are listed on the National Register of Historic Places, the nation's official list of cultural resources considered worthy of preservation and protection. The Wiley-Ringland House was built in 1893 by town founder Dr. Harvey Wiley, and Mr. Arthur Ringland, known as the father of CARE, later lived in it. Badly damaged by fire in the 1970s, the home was renovated and added to the register in 1999. (Courtesy Katherine Kosin.)

The Salmon-Stohlman house is also listed on the National Register. One of the first five Somerset houses, it was built for Dr. Daniel Salmon—head of the Department of Agriculture's Bureau of Animal Husbandry—as a summer house. In 1902, John W. Stohlman, owner of the Georgetown Bakery and Confectionery and the town's fifth mayor, purchased the house. He owned it for almost half a century.

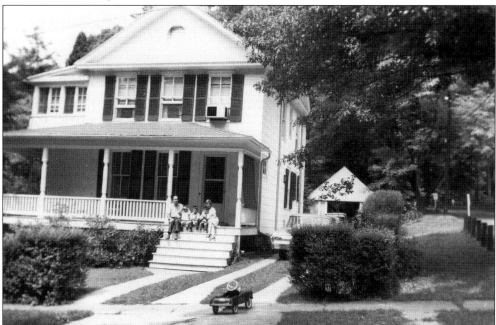

When the Schneider family bought the home in 1962, Zola Schneider recalls, "We couldn't get a 30- or even a 20-year loan because the lenders all thought the house was too old!" The house, which was built for speculation by Edward Halliday around 1901, still stands today in the midst of Somerset's historic district as firmly as it ever did. (Courtesy Zola Schneider.)

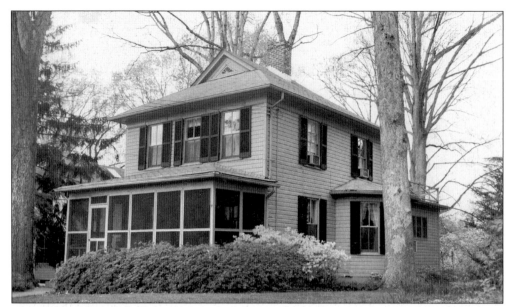

This is one of three standardized houses built on Cumberland Avenue by Alf Ough around 1901. Frank P. Dudley and his family lived here from about 1910 on. The Dudley kids would watch the gauge mounted on the side of the water tank across the street, and Henry Dudley would recount years later how he and his brother "went down the hill at all hours to start the gasoline motor to pump the water up the hill to the tower." The front porch has been screened in, and there is a rear addition in this 1987 photograph; otherwise the home's turn-of-the-century architecture is unchanged. (Courtesy Diane Cross.)

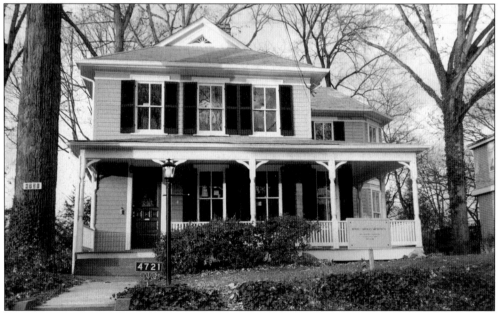

Leland Martin Jr., his wife, Lucile, and their family lived in the home for more than 30 years before selling it to Christopher and Diane Cross in the 1980s. The Cross family undertook extensive renovations and additions to the property. The much-enlarged house retains a good sense of the original front façade. (Courtesy Diane Cross.)

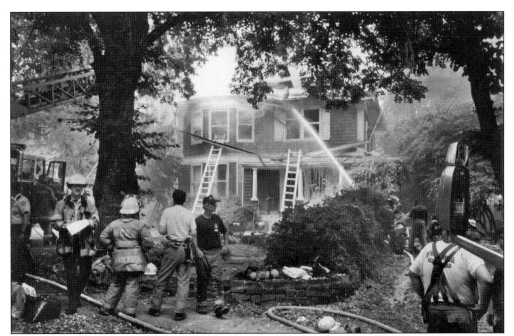

This 1906 house on Cumberland Avenue was the victim of an extensive fire on July 8, 1996. Painters using a blowtorch to burn off old paint started the blaze. Several fire trucks responded within minutes of the call, and, despite significant damage, the house remains today, extensively renovated and enlarged. (Courtesy Zola Schneider.)

The McNish house on Essex Avenue, built in the 1930s, was torn down in the 1990s. This was the harbinger of a new trend: older homes making way for more modern and often much larger homes—a trend that some applaud and others bemoan. The McNish house had been built on a double lot and was replaced with two houses of modern architectural designs that promoted a wide range of views from neighbors. (Courtesy Joan Weiss.)

The Byron house, built in 1995–1996 on the McNish side lot (the McNish property can be seen to the right), was considered large at the time. At 4,000 square feet, this energy-efficient, post-and-beam construction, which features universal design, is modest by today's standards. Originally designed 35 years ago by modernist architect William Berkes, the home was featured in the 2000 Tour of Solar Homes. (Courtesy Howard Byron.)

More than 100 Somersetters gathered at the town hall to celebrate the town's 90th birthday in 1996. There were two large cakes, an exhibit of historic photographs and news articles, a variation on the happy birthday theme at the piano by Louise Kupelian, a talk by popular Bethesda historian Bill Offutt, and reminiscences by pre-World War II residents, including Tom Capello, James Cremins, Ralph Crump, Don Gish, the Hambleton sisters, Art Hummel, Bill Smith, and Rita Verkouteren.

In another celebration the following year, 150 Somersetters bid a fond farewell and presented a commemorative plaque to foreman Gene Tillman, who had joined the town staff in 1957. He shoveled snow, installed street signs, mended swimming pool chairs and tennis nets, cut grass, vacuumed leaves, and painted crosswalks for four decades with five mayors, six clerk-treasurers, and scores of council members. (Courtesy *The Gazette* newspaper.)

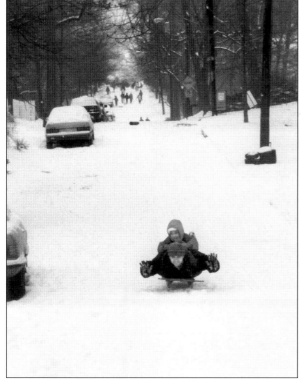

January 8, 1999: a snow storm dumped enough white stuff for the fourth generation of the Krynitsky family to enjoy a sled ride down Cumberland Avenue hill. In this photograph, sister Stephanie rides on top of brother Jonathan. It also left Somersetters without electric power for three to four days, depending on the grid each home was on. (Courtesy the Krynitsky family.)

Uncle Sam welcomes Somersetters to their July Fourth picnic on the town hall grounds in 1998. July Fourth celebrations have been special since Somerset's earliest days. Sylvia Carrigan Smith remembers the first one at the turn of the 20th century. "There were races and contests of all kinds, some for children and some for adults . . . and then later everybody assembled on the field and ice cream was served. When it became dark the fireworks were displayed. There were other 4th of July celebrations but none to equal that first one." (Courtesy Maurice Asseo.)

At the end of the century, Somersetters still gathered for a picnic, games, and ice cream—and now a traditional parade to the pool for still more games. In 1997, Howard Byron began a new tradition: an antique car show (cars 20 or more years old welcomed), which has been a popular side show ever since. (Courtesy Maurice Asseo.)

The town got its own flag when town resident David Herbick submitted the winning entry to a 1999 competition. His flag depicts the Red House Town Hall and the big trees that Somerset is known for. It flies over the town hall porch, stands with the Stars and Stripes and the Maryland state flag at town events, and is here carried by Clerk-Treasurer Tom Carter in the flag parade at the Maryland Municipal League's convention.

A town history committee was established in 2002. Here town residents share memories at the second annual Somerset History Day, which was organized by the history committee and held in the town hall in April 2003. From left to right are council member Judy Frankel, unknown, and Sue Beshrov (winner of the 2003 History Quiz), George Harman (peeking over Sue's shoulder), and Alice Rowen at the microphone.

These pillars were built in 1935 to replace the stone wall, pillars, and shelter entrance that had guarded the then-sole entrance to town since the early 20th century. Barbara Carruthers remembers climbing them in the 1940s to wait for her friends' moms to bring them across Wisconsin Avenue to play with her. A 2003 renovation, necessitated by widening the entrance to meet modern traffic needs, won the town a Historic Preservation Award. (Town of Somerset collection.)

In May 2004, the mayor accepted a Historic Preservation Award on behalf of the town for its work on restoring the entrance pillars in a way that contributed to the preservation of the county's historic resources. From left to right are Somerset mayor Walter Behr with the preservation award; Julia O'Malley, chair of the Montgomery County Historic Preservation Commission; and Wayne Goldstein, president Montgomery Preservation, Inc.

The pool became even more popular when the annual swim fee was dropped in 1997. The swim team grew with leaps and bounds from 40 kids in 1997 to 146 in 2005. It has grown in stature, too. The Dolphins were in the league's N-Division in 1997, moved to M in 2000, K in 2002, J in 2004, and I in 2005. (Courtesy Irvin Simon Photographers.)

Somersetters love the summer, when the pool gives kids and adults alike many opportunities to get together with friends and neighbors. Over the years, the pool season has slowly lengthened as residents resist ending their swim season. But in the end, there must be a sad farewell to the dog days of summer. An afternoon pool party breaks the spell, and, as dusk comes, Somerset dogs are allowed to swim one time before the pool is closed for the season. (Courtesy Julie Greenberg.)

INDEX